creative ESSENTIALS

Celia Brayfield

ARTS REVIEWS

...and how to write them

creative ESSENTIALS

This edition published in 2008 by Kamera Books
an imprint of Oldcastle Books,
PO Box 394, Harpenden, Herts, AL5 1XJ
www.kamerabooks.com
Reprinted 2015, 2017

Copyright © Celia Brayfield, 2008
Series Editor: Hannah Patterson

The right of Celia Brayfield to be identified as the author of this work has been asserted
by him in accordance with the Copyright, Designs and Patents Act of 1988.

All rights reserved. No part of this book may be reproduced, stored in or introduced
into a retrieval system, or transmitted, in any form, or by any means, (electronic,
mechanical, photocopying, recording or otherwise) without the written permission of the
publisher. Any person who does any unauthorised act in relation to this publication may
be liable to criminal prosecution and civil claims for damages. the book is sold subject
to the condition that it shall not, by way of trade or otherwise, be lent, re-sold, hired out
or otherwise circulated, without the publisher's prior consent, in any from or binding or
cover other than in which it is published, and without similar conditions, including this
condition being imposed on the subsequent publication.

A CIP catalogue record for this book is available from the British Library.

978-1-904048-91-6 (print)
978-1-84243-418-5 (epub)
978-1-84243-488-8 (kindle)
978-1-84243-419-2 (pdf)

Typeset by Elsa Mathern
Printed and bound by 4Edge Ltd, Essex

CONTENTS

PERMISSIONS

Extract from *That's Me in the Corner* by Andrew Collins, published by Ebury, reprinted by permission of the Random House Group Ltd and the author.

Extract from review by Dirk Bogarde of Gretchen Gerzina book, June 18, 1989, reproduced by permission of the Telegraph Media Group Ltd.

Extract from review by Mark Kermode of *Pirates of the Carribbean: Dead Man's Chest* in *The Observer*, July 9, 2006, copyright Guardian News & Media Ltd, reproduced by kind permission.

This book is dedicated to Sir Simon Jenkins, with grateful thanks for his inspiration, his example and for giving me my first job as a reviewer.

ARTS REVIEWS

...and how to write them

INTRODUCTION

Most reviewers wake up every morning and can't believe their luck. They're getting paid to do what many of them would actually bribe someone to let them do anyway. They are going to be rewarded for indulging an obsession. Ahead of them is a day which they can devote to the activity that, with the possible exceptions of sex and food, they love best in the entire world. This they will be able to describe as their work. Truly, whoever called being a reviewer 'the world's best job' was not wrong. The role offers you an irresistible balance of passion, pleasure and lack of responsibility. And you may well get paid for it. Life doesn't get much better.

In this book I will be talking about reviewers rather than critics, although the terms mean almost the same thing. Of course the choice of word is deliberate – I'm a writer, I choose words as other people choose washing powder or life partners, for their essential qualities. Critic may be the traditional name for the person who is a professional audience for an art, but it sounds a little negative and the baggage that comes with it is heavy and ugly. I am also an artist; people talk about constructive criticism but, to the artist, the stuff in the media is rarely that. Artists do not often experience media criticism as a positive contribution to their work.

Critic is a also narrow word; it doesn't suggest the central role that reviewers can play in championing, advancing, popularising or refining

the art that they love. Their influence can be profound. Quentin Taran-tino acknowledged his debt to the film critic of *The New Yorker*, Pau-line Kael, whose notices he read faithfully while growing up, saying that she was, 'as influential as any director was in helping me develop my aesthetic'.[1]

Here is Sir Tom Stoppard explaining that when he began to write plays they were directly influenced by the *Observer*'s drama critic, Kenneth Tynan: 'Tynan mattered for his youth, his virtuosity in print, his self-assurance, his passion and above all for his self-identification with the world he wrote about. So... when I sat down to try to write a play, I was consciously trying to write for him.'[2]

Perhaps the most thrilling moments in a reviewer's life are the times when it falls to you to be a witness to history. A young soprano appeared in an obscure opera at the Olympia Theater in Athens and one of the critics who heard her, Vangelis Mangliveras, wrote, 'That new star in the Greek firmament, with a matchless depth of feeling, gave a theatrical interpretation well up to the standard of a tragic ac-tress. With her exceptional voice with its astonishing natural fluency ... she is one of those God-given talents that one can only marvel at.' His judgement was so apt that Maria Callas was known afterwards as 'The God-Given' even by the rivals who hated her.

A great critic, says the music reviewer Norman Lebrecht, is 'the conscience of his art'. Individual critics have left their distinct imprints on our creative life; their confident judgement and their intelligent support can define a great artistic movement and create the con-sensus that will recognise it. Groups of critics, brought together by the beliefs and values that they share, have deliberately steered their culture in a new direction. Even before that, great critics contributed immeasurably to the cultural life of their times, informing, challenging and stimulating their readers to a better understanding of the arts.

Many artists begin their careers as reviewers. Early in their creative lives, when they have yet to mature as practitioners, they have a pas-sion for their field and often also a clear idea of where it should be

going. The most striking example of a creative movement which began as an exercise in criticism is the cinema of France's New Wave; a handful of iconoclastic youths attacked the timid, traditionalist French films of the 1950s in a new film magazine, *Les Cahiers du Cinéma*, and almost instantly became the legendary directors creating a new cinematic style. As a reviewer, a developing artist becomes part of a creative profession, gains an understanding of its dynamics, meets the key players, falls in with like-minded friends and has the opportunity to issue a manifesto in every notice.

Equally, many reviewers don't cross over to the creative side, either by choice or because they're in the wrong place at the wrong time. As a young film critic, I would have liked nothing better than to become part of the British film industry, but at the time there wasn't one. True, a few movies got made; it was a phenomenon like the desert rivers of the Middle East. After a long, cruel, dry spell there would be a flash flood; people would hail a new British cinematic movement and then, as with a wadi in the desert, the essentials – faith or money or tax breaks – would dry up, leaving only the name, the erosion and maybe a bleached skeleton to show where there had once been abundance.

You didn't have to be a man to work on this now-you-see-it-now-you-don't enterprise but almost all the writers, directors and technicians were male. Since the work was scarce, they were fiercely protectionist. The real action in movies was not in London, but in Hollywood, Paris, Warsaw or Rome, and I had a depressing sense of being a long way away from it. So when a desperate magazine editor offered me half a page of film reviews every month if I'd deliver a spread on television as well, it was a blessing in disguise. The British film industry probably lost the dreamiest production assistant it never had.

Having struck, as I saw it, a downright Faustian bargain and become a television reviewer, I found myself part of a golden age. Better still, few writers of any calibre in the press knew anything or cared less

about this Cinderella backwater of the entertainment industry – that was the reason that my editor resorted to Mephistophelian manoeuvres. Overnight I became a media authority and in a few months I was headhunted by Fleet Street and spent the next seven years with the brightest, most creative and most exciting screen talents of the time.

It was strange to operate in the no-man's-land between television and newspapers, territory that was heavily mined, full of barbed wire and shell holes, haunted by the ghosts of decent writers who had died under fire. TV was then and currently remains the dominant information medium, with 95% of the population relying on it for news coverage, a fact to which newspapers at that time were responding with dour resentment. Every year the television industry creamed off the top graduates from Oxford and Cambridge, yet the editors for whom I worked dismissed their work as lowbrow mass entertainment, unworthy of their attention and of no interest to our readers. When I thought about this attitude in relation to the significance of the industry, I felt as if my head would burst with the absurdity of it. So I went to war. Stories were my ammunition. I bombarded my editors with reportage, features, profiles and essays. Most were shot down, but gradually the section editors realised that I could deliver something halfway interesting and competently written that would plug the holes in their schedules.

I was working on an evening newspaper that had a classic problem with reader loyalty. Typically, people bought the paper only once or twice a week, on their way home from work, instead of getting it every day as the readers of morning papers tend to do. I knew, as an avid reader of the critics since my teens, that a good review needs to stand alone, meaning that it should be understandable to a reader who hadn't followed any continuing debate around its subject. So I made sure that my work always passed that test, even when I was writing the TV listings.

I also loved reviewers who brought deep erudition to popular art, like Clive James, whose TV reviews glittered with running gags based

on the absurdity of *Dallas*, and Alexander Walker, whose film criticism took his readers inside the live debates in the industry. Banned from studying the arts by my father, I had educated myself covertly from such erudite critics, disappearing into the recesses of the school library with its hallowed copy of *The Times* or rowing upriver on summer holiday mornings to buy the Sunday newspapers. I learned of Fellini from Dilys Powell, Diaghilev from Richard Buckle and Wagner from Bernard Levin. Naturally I set out to emulate my heroes, so I pitched my work far higher than the traditional TV writer, assuming that my readers were hungry for fun and for facts, and ready for a wider perspective on a medium that they took seriously even if my editors did not.

Soon I was getting fan letters and, even more impressively, the paper was getting sales. One of the most rewarding sights of my life appeared as I sat anonymously on a commuter train watching a passenger who carefully tore my column out of the paper, placed it reverently in his wallet and threw the rest of the newspaper away when he left the carriage.

After years of writing the editor passionate memos about What The Paper Needs I was allowed to launch the first media supplement in a British newspaper. It was immensely satisfying to be the first to spot a hit new series, to understand a new cult, to promote a gifted documentary-maker, to spotlight a stunning young actor or to champion a brilliant comedy performer who just hadn't had the right break yet. The people I wrote about now run the British TV industry or else they've justly become international stars: Michael Grade, Greg Dyke, Melvyn Bragg, Jane Root, Michael Apted, Stephen Frears, Julie Walters, David Jason, Jeremy Irons.

When I got the confidence to write my first book, I found that I could draw on a reservoir of goodwill in high places. Many doors opened even before I knocked on them. My first publisher was one of my readers and actually asked my agent if I'd like to write a book for her. When I needed to approach major celebrities for interviews, their gatekeepers often reported back, in wondering tones, 'He said,

"Oh, I know Celia, I like her stuff, yes, tell her I'll do it".' By that stage, I also knew many of the gatekeepers and had managed to win their respect too.

Crossing over into TV would have been nice but almost impossible. You didn't have to be a man to work in the industry at that time but the overwhelming majority of the people who did were male. Or else they were at least pretty; some, indeed, were the great beauties of our day, while I had an excellent face for radio. So when the day came that I woke up and realised that I wanted more, I went back to what I knew I was good at and became a novelist and had the interesting experience of being reviewed in my turn.

I soon discovered that book reviews turned out to be a great denominator of genius; when they were reviewing, first-rate writers had always read my books attentively and understood them, even if they found it alarming that they were international bestsellers. Second-rate writers read the blurb, the first page and, sometimes, the end, but felt free to advance devastating critiques on this flimsy basis.

Reviewing doesn't have to be a vocation. It can be the first writing job you land just because you're so determined to become a journalist that you'll write anything anytime anywhere for anyone, just to get started. This is an excellent attitude and will often lead to professional success. If you don't want to become a journalist that badly, perhaps you should reconsider your career choice because you'll be competing with a large number of people who are passionate at that level.

So your first review may come your way because you're the only person in the office willing to junk your plans for the evening and trek off to some poxy fringe venue in a gang-crime hotspot to review an act you've never heard of and miss the last train home, all in the cause of Art, filling up a quarter of a column in your publication, and – aha! – getting a by-line. Even before that, the ability to write a review that provokes people to read and respond can be your best chance of getting published on a fan site that's doomed to disappear three months later but will leave you a by-line when it goes.

What's a by-line? It's the line that starts with 'by' and ends with your name. It's your credit for writing a piece of journalism, the proof that someone with editorial authority has deemed you sufficiently interesting and responsible to be able to advance your own opinions under your own name. 'By' plus 'your name here'. In the media, a by-line is what you need to get started. Once one editor has given you a by-line, you're in the game and others will follow.

One day, you may become the editor, giving out by-lines in your turn. One day, your name may appear in cultural essays, authoritative biographies or the credits of top-rated arts shows. One day, you may be staying up late to read the first editions of the newspapers as they come up on the Web carrying reviews of *your* own film, or *your* novel, *your* art installation or *your* groundbreaking new production of *Die Walkure*. Whichever route you choose, it starts here, with the secrets of writing a great arts review.

1. WHAT MAKES A GREAT REVIEW?

A review can be a 2,000-word, state-of-the-art epic illustrated with a glossy photo-spread and splashed over four pages in an upmarket magazine with an international readership. A review can be a 150-word near-haiku included in a round-up of summer beach-reads in a local newspaper. It is probably easier to attain a towering reputation as a reviewer if your work fits the first of these formats, but you will probably start with the second. Of course it's a challenge to shine in a space the size of an iPod Nano but writers do that. A great review doesn't need space; usually, however, it does need to touch base with the following six qualities.

ARRESTING

Like all great journalism, great reviews grab the readers in the first half-sentence. Lord Beaverbrook, the legendary Canadian press baron of the mid-twentieth century, used to tell his reporters to 'Put your best strawberries on top,' meaning that they should lead every piece with the most attractive fact in the story. We will discuss the techniques of compelling writing later in this book. For now, let us just state that the No 1 attribute of a great review is its outstanding, up-front readability. It will stop you dead, grab your attention, tempt you, tease you, impress you and insist that your life will be poorer if you

don't read the story to the very last word. As does this introduction to a television review by Nancy Banks-Smith of the *Guardian*:

> It was like stepping on a cat. The reaction was instantaneous. The moment James Hewitt arrived at his shirt makers ('by royal appointment') and had his credit card queried, I knew who he reminded me of. Of course, this was Burlington Bertie, the charming but impoverished toff, who once had a banana with Lady Diana.
>
> After a long, liquid, alfresco lunch, he affably explained the purpose of the programme to passers by. 'They're doing it about me because I'm a complete shit, and we're trying to make me less of a shit. And it's not working!' A fair enough summary of *James Hewitt: Confessions of a Cad* (Channel 4). He was fortunate in his producer, Mike Warner, who saw the funny side of Hewitt and, sometimes, the depression.[3]

INTERESTING

Well, yes. Obviously. A reviewer who has got the readers' attention must then work twice as hard to keep it to the end of the piece. 'You should entertain, amuse and touch people,' says Anthony Quinn of the *Independent*, considered to be the film critic's critic but also a respected literary reviewer who was one of the judges for the 2007 Man Booker prize.

Every publication tries to estimate the proportion of readers who are lost in the course of reading a piece. Web editors talk about the 'stickiness' of a feature, meaning the number of pages which a visitor will click through to after the first hit. Methods of measuring page traffic differ but the chilling result is always the same – the drop-out rate is huge. On my own newspaper the surveys showed that while 98% of readers would look at an article's headline, maybe 60% would then begin the piece, but only 3% would finish it.

So – how to be interesting? Do you have a sinking suspicion that

if you need to ask that you must be a natural-born bore? Excellent. Worrying that you're being boring is where you start to get interesting. It's a tough quality to define but you know it when you read it: the previous quotation, despite its elegance and wit, manages to feature sex, royalty, shopping, a dodgy credit card and bad behaviour in two little paragraphs. For the majority of the readers in our developed world that formula would work pretty well, but it would be hard to apply to a recording of the *Brandenburg Concertos*. Worse, a bad writer can tick all those boxes and still send the readers to sleep in two sentences.

Reviews can be immensely entertaining, especially the bad ones. There's nothing quite as amusing as breathtaking bitchiness in print. You read one of the great pannings of all time, such as Mark Kermode's condemnation of *Pirates of the Caribbean II*, and because it flows as irresistibly as the Mississippi and sparkles like chilled Kristal you imagine that writing like that is easy. Then you set out to compose your own killer notice and find that you run out of words for 'boring' after the first paragraph.

That little word 'interesting' implies more than half the art of writing. To offer your readers prose that is glowing, supple and totally irresistible you need a rich vocabulary, a lyrical sense of language and the ability to build, refine and display an argument. You need to express strong feelings in a vivid vocabulary. You need to be able to educate your readers without them knowing it and win their sympathy while seeming not to care what they think. You need a well-developed sensitivity to their attitudes, for as many readers check out because they're offended, as give up because they're bored.

AUTHORITATIVE

A reviewer writes as an expert. Even when a reviewer pretends to be responding as a simple, ordinary member of the audience, she or he is in fact writing with the benefit of privileged information, accumulated experience, and often with academic knowledge as well. These

three attributes give a reviewer the special insight which in turn establishes his or her authority with the reader. A reviewer, by definition, knows more and knows better. She or he has a sharper perception of form, a more rigorous understanding of content and a sophisticated perspective on the artistic context of the work. Therefore, a reviewer's opinion has more merit than that of an ordinary person. As reviewing is increasingly democratised through interactive enterprises like blogs and review sites, so the premium on a critic's authority has risen; it's the one thing we can offer that the average representative of the cyber-rabble can't match.

How does a reviewer project this authority? In some fields, notably the visual arts, reviewers have almost developed an elite dialect of critical terms in which to discuss the works in question. They use a privileged vocabulary, often to the extent that a casual reader cannot follow their argument without asking for explanation. They refer to critical theories and assume their audience has a large body of knowledge from which to understand the context of the work.

These strategies are not necessary to demonstrate the writer's authority but in some fields they are customary. What is necessary is for the reviewer to make his or her expertise clear to the reader. Often this is done simply by offering readers the extra information that will allow them to appreciate the work more fully. It takes different forms in different media; a film review in a celebrity magazine will mention the latest gossip about the stars, a film review in a serious cinema periodical will refer to the director's previous work.

PROFESSIONAL

A great review is also a great work of journalism and stands the tests of accuracy, balance and concision. Accuracy implies not only getting the facts right but also including the essential information about a work. Balance presents a reviewer with a series of challenges which we shall explore in more detail later. Reviewing is more of a balancing

act than any other role in journalism. A reviewer is always a servant with at least two masters and often more. Between the art and the medium, between artists and editors, between the simple passion of an aficionado and the complex responsibilities of a reporter, a reviewer needs to make difficult decisions. Every individual draws their own line. Some adopt extreme measures to maintain intellectual detachment; others plunge over their heads into the world of their art.

Concision is a hard discipline but one that a writer must learn well in order to be a good reviewer. An experienced journalist's first question is always, 'How many words have I got?' Beginning journalists often imagine that it is right to give an editor more words than they have requested. Big mistake. Editors like nothing better than copy written exactly to length. They do not like having to perform major surgery on a self-indulgent mess of writing when the edition deadline is 30 seconds away. If editors need a couple of extra paragraphs to have in hand in case their layout changes during the production process, they will ask for them by including them in the word count. Most copy is cut and the wise writer balances the piece carefully within the given length.

PERSONAL

Objectivity has only a small place in criticism. In fact, the essence of great criticism is the writer's love affair with the art. As Norman Lebrecht says,

> Great critics take their seats, whether in a Soho studio on a Monday morning or at the Metropolitan Opera on gala night – prepared to fall in love. They may despise the producers and question the credentials of every cast member but when the lights go down their breathing quickens like a child's on its birthday. Their verdict may amount to defamation and damnation in a brutal phrase that will resound for a generation. But the loathing they vent is the effluence of love, of an all-consuming love ... The echo of that love is the legacy of a great critic ... an unconquerable optimism, a faith without doubt that art can redeem the miseries of mankind.[4]

27

A reviewer's response is essentially and inescapably subjective but a great reviewer manages to define an identity so precisely that readers can relate to the writing as they would to a person. Readers will not necessarily agree with a critic, but they will enjoy the vitality and precision of a well-developed critical voice and they will form their own judgement of the work in relation to the critic's stance.

As a new writer, nothing mystified me more than the emphasis that writing tutors place upon the 'voice'. I had written a succession of well-reviewed books without ever giving a single thought to my 'voice'. Telling a writing student to develop a voice seemed as unhelpful as asking them to think of a funny joke or name six famous Belgians. Just asking makes the mind go blank. In fashion, the equivalent impossible was 'style'. Style is something that models are adored for having but which you can't teach anyone to develop. Same with voice. A writer develops a voice by writing, by putting stuff on a page that pleases them and deleting stuff that doesn't.

Confidence grows with the voice. After a while, you get a sense of what pleases you. The next step is to find out what pleases your readers. Self-delusion is death at this point. One of the famous factoids about Marilyn Monroe is that she scanned her contact sheets and her rushes obsessively, seeing what worked for her and what didn't. Legend does not record that she looked over her pictures and decided that it was the photographer's fault that she looked bad with frizzy red hair. Similarly, a writer should be sensitive to how their writing is received and, if readers are bored, confused or offended, they should not place the blame for that anywhere but with themselves.

APPROPRIATE

As we have already considered, reviews are carried by a very wide range of media and so presented to very different readerships. What is considered a good review in a venerable film magazine such as *Sight & Sound* will bore the readers of *Hello!* senseless.

Every medium has a conception of its audience and most have a strong imperative to deliver a target readership to its advertisers. Very few media are financed by sales; while the cover price may be a significant element in the revenue of a well-established city newspaper, most of a medium's income is derived from advertising and those who plan media campaigns choose to advertise in a certain medium because it has the right readership profile for their product.

This means that every journalist feels the imprint of the news values and editorial style of the medium for which they are writing. The subject, content, language and opinions of a review will all be appropriate for that medium. It is essential for beginning writers to understand this; the belief that the obvious brilliance of your writing will over-ride news values is misguided and will collect rejections as long as you hold it. In many cases the most successful journalists are natural partners for their publications, with the same values, interests and lifestyles as their target readers. Thus Toby Young writes effortlessly for highly educated, somewhat right-wing readers of London's *Spectator* magazine while Derek Malcolm was just fine with the left-wing cineastes reading the *Guardian*.

Appropriate writing immediately creates a bond with the reader. Here is the novelist Martin Amis reviewing a book about the fan culture of football for a rigorously high-toned literary periodical:

> Readers of the London Review of Books who like football probably like football so much that, having begun the present article, they will be obliged to finish it. This suits me down to the ground. Pointy-headed football-lovers are a beleaguered crew, despised by pointy-heads and football-lovers alike, who regard our addiction as affected, pseudo-proletarian, even faintly homosexual. We have adapted to this; we keep ourselves to ourselves – oh, how we have to cringe and hide! If I still have your attention, then I assume you must be one of us, pining for social acceptance and for enlightened discussion of the noble game. This puts me in the happy position of not really caring what I write.[5]

2. FIRST THOUGHTS

Arts reviews are carried by websites and blogs, national or local news-papers, magazines, television programmes or radio. Later in this book we will study the special demands of the different media and offer you strategies for adapting your performance for each. This chapter starts with the principles that hold good across the whole spectrum, the essential skills of writing a review. Whatever medium you work in, you will write something, even if it's only notes to fuel a filibuster on late-night TV.

The rules I'm about to lay down apply to any form of journal-ism, whether it is news reporting for a local free-sheet or writing an elegantly turned feature for an upmarket Sunday supplement. 'I'm not a film critic,' says Cosmo Landesman who reviews for the *Sunday Times*. 'I'm a journalist who writes about films.' The process, the chal-lenges and the secrets of success are the same. Writing is only part of the operation; first you need to prepare, and when you've written a first draft you will need to revise.

One thing that arts reviewing can have in common with news re-porting is time pressure. Daily newspapers still run rock or theatre reviews on their news pages, keeping the space in the layout for late copy filed from the critic's laptop in her car. In the theatre, there is a stately tradition that a press night performance starts at seven and runs for at least two-and-a-half hours, giving critics a tight half-hour

to meet the deadline, which will be around 11pm. In rock music there is a fine tradition of performers being late on stage, so the rock critic with the same deadline can be plain stuffed. Thus reviewers learn to think on their feet and file from their Blackberry if they have to. This can be an extreme experience.

Andrew Collins, in the third volume of his memoirs, *That's Me In The Corner*, recalls covering Britain's biggest rock event, the Glastonbury Festival, when he was reviewing for the legendary music weekly *New Musical Express*, known as the *NME*. A new editor decreed that a skeleton staff of two should attend the three-day event, which is held on a farm deep in the mystical landscape of the South West of England; their mission was to see and interview every act there and write a four-page report overnight.

In 1992 ... I slept in the car. Worse, I slept in the car in the backstage paddock. I had crossed the line. My journey from punter to ligger was complete.

Was it a good Glastonbury? Well, it was dry. And for the *NME*, it was an experiment. One that went horribly wrong and had far-reaching consequences.

This is how it worked. As the event had expanded over the years, more and more writers had to be dispatched to different stages and different tents on different days in order for the paper to boast full coverage. But with the festival finishing on the Sunday night it was impractical for the *NME* to get that coverage away in time for the following week's paper, which 'went to bed', to use the print trade parlance, on the Monday. It hit the printers on the Tuesday and came back in those exciting bundles tied with string on a Wednesday

So why not get the writers to file their copy on a Monday morning? Because it was considered too risky to rely on such a large ensemble of hacks to each come down off their festival cloud and deliver anything readable overnight ... By the time Glasto coverage appeared, a week and a half after the festival, it was the very definition of old news. End of story.

Enter Danny Kelly (*NME*'s new Editor) in his scorched-earth ideas juggernaut ... He had quickly established himself as a bold, fearless, noisy leader. In 1992, he made a bold, fearless, noisy decision. He would dispatch just TWO writers to cover the entire 1992 Glastonbury Festival. Let's run through those figures again: TWO writers. These trusted captains would spend three days on site, soaking up the sights and sounds, return to civilisation on Sunday and write the report up OVERNIGHT, delivering their joint Conradian epic on Monday morning. For the first time in its forty-year history, the *NME* would have its Glastonbury coverage on the news stands by Wednesday... It was revolutionary.

...Those captains were myself and David Quantick. Can-do features editor and veteran freelancer. The dream ticket. What could possibly go wrong?

We planned it like a military operation using maps, charts, highlighter pens and tiny models of ourselves: for three days, Quantick would be wherever I wasn't, and vice versa, all the while on the move, like sharks, taking copious notes and snatching interviews with the stars. We arranged to rendezvous at the backstage beer tent on Sunday afternoon, from whence I would drive back to London in my Vauxhall Nova. We would hammer away at a hot keyboard all night and I, the responsible staffer, would hand-deliver our dynamic, vivid, evocative, Hunter S Thompson-style copy on floppy disk to the offices of the typesetters the next morning. I would then oversee the layout with Danny... at the coalface.

... The *NME* would provide a unique service. We would confound expectations by turning round yesterday's news today. We would DELIVER. More importantly, we would beat Melody Maker, our arch-rivals-owned-by-the-same-company-whose-office-was-one-floor-away-and-who-ate-in-the-same-canteen-as-us. That would show 'em.

By the end of the festival, I realised that Quantick had certainly been everywhere I wasn't ... His notes resembled the hieroglyphics of a serial killer in the last stages of mania before being caught. The only audible think on his tape was an exclusive interview he'd conducted with our old editor ... WHY? WHY? WHY?

Unfortunately, he'd found himself with the House of Love in a marquee that served complimentary Pimm's. The height of perceived sophistication this sticky, reddish, gin-based drink might be, but by the bucket it will set you, like Quantick, on the road to ruin...

I'm not claiming to have been a choirboy myself, but at least some of my notes were in English. (Back in London) I typed and Quantick mostly slept. Without recourse to stay-awake drugs, we finished the piece before breakfast and I took it to the typesetters by hand. Quantick went home to get some more sleep. The great thing about a tight deadline is that there's no time for quibbling over the small matter of quality. The mere act of punctual delivery brings praise and gratitude. This may, indeed, be the secret of a lasting career in journalism.

So we'd done it. Mission accomplished. We'd met the deadline, fulfilled our brief, produced four pages of impressionistic rubbish and revolutionised festival coverage for music weeklies for ever. Never mind the quality, feel the width.

The sound of backs being slapped and corks being popped continued for some time. Actually, it continued for a very specific amount of time: until the new issue of (a new music magazine) *Select* came out ten days later. With sixteen pages of Glastonbury coverage in full colour. Witty, evocative, vivid, literate, arch, colourful ... (One of their readers responded) 'I had to write and congratulate everyone involved with the Glastonbury review. It was amazing! All the other 'weakly' papers totally bollocksed their reviews up.'[6]

Traumatic as the experience was, it led to a happy ending for Collins; by the end of the year, he'd been headhunted by *Select* to be their new features editor.

PREPARATION

Reading

All writing begins with reading. If you want to write reviews, you must read reviews. This book will give you some ideas of the great reviewers,

past and present, whose work will help you achieve an organic, unconscious understanding of what a great review really is. The smart thing would be to identify the writers you like and read a lot more by them.

Margaret Atwood, the Canadian poet and novelist, describes learning from reading as a process of osmosis. Scott Fitzgerald, writing to his daughter, suggested that as a teenager she should aim to 'put six first-rate writers in your head' every year if she wanted to form a good writing style.

Reading as a writer does not mean consciously copying the author who you choose to study. You can do that too, of course. Pastiche writing is enormously instructive and, if you're good at it, terrific fun and immensely entertaining. At the start of my career, when I shed a bucket of tears every day because my copy was rejected, I resorted to shamelessly copying the newspaper's star columnist and guess what? My editors said I'd improved enormously. Soon they had such confidence in me that they barely touched my copy and I was free to write in my own style, although I'm sure that style had evolved in relation to the columnist on whom I temporarily modelled my writing.

Not everyone has a facility for pastiche. Mimicking another writer is not the same thing as allowing wonderful prose to teach you as you read it. All that's necessary is to read and experience their work simply as a reader. Your memory will hold the form, the tone and the structure of great writing as an emotional imprint rather than an intellectual idea and you will gradually acquire the ability to give your own work the qualities that you admire in that of other writers.

It is particularly important to read the most highly acclaimed or influential critics who are working in the field you want to enter. Criticism is as ephemeral as a butterfly. It is absolutely of its moment and rarely stands the test of time. When this book asks you to examine the work of great reviewers who were writing in past decades, you will appreciate immediately how much language changes, style changes and the arts change. Fifty years ago, a reviewer was expected to refer to a performer as 'Mr Jagger'. Nowadays, plain 'Mick' is the form,

with 'Sir Mick' reserved for ironic use. So while it is worthwhile mak-
ing the leap of imagination that we suggest you attempt later in this
book, to study the work of great critics from past decades, it will not
serve you well to pick up an archaic vocabulary and arthritic syntax
in the process. Your role, as a new reviewer, will be to move the art
of reviewing forward and to do that you need a solid appreciation of
where it stands now.

You may well hate the work of today's leading critics; that would be
a healthy response for a writer who intends to knock today's cham-
pions off the podium. However, their work expresses the current con-
cept of excellence in your area and if you can understand why you will
be in a much better position to take their crown.

Keeping Up

The major criticism levelled at entrants into journalism is that their
knowledge of current affairs is weak. Editors have no sympathy for the
tender years and low horizons of interns who were only undergradu-
ates last week. Our leading playwright, Sir Tom Stoppard, would have
begun his career on London's *Evening Standard* if the editor hadn't
asked him if he was interested in politics. Stoppard said he was, and
the editor then asked him to name the Home Secretary. Stoppard
had no idea what to say and protested that he was only interested in
politics, not obsessed. So he didn't get the job.

Working journalists consume media constantly. A newsroom twin-
kles with TV screens like a Christmas tree hung with fairy lights; in
addition, editors read six or seven newspapers every day, plus another
half-dozen political or scientific journals every week, plus a stack of
on-line material from news agencies, lobbyists, academics and public
relations companies. And if they commute, they listen to the radio
news and the features following it on the way. And if they go out to
lunch, they recirculate all that information in light conversation over
the bruschetta. There is no greater sin in this profession than to be out

of touch with the day's events in your field, whether that means the latest news from Iraq or the colour of Paris Hilton's new handbag.

This obsession, to use Stoppard's word, is not an affectation but an essential habit of mind for people whose role in society is to know what's happening and tell the rest of us. Until you begin to write for the media, you will not truly understand how impossible it is to do so with flair and confidence if you lack a broad understanding of what's going on in the world. Your copy will be dull if you're uncertain of the context of your subject, and you will never be able to write with authority and win your readers' respect. Furthermore, if you have to write against the clock, you simply can't afford the moment of hesitation that uncertainty will cause and you certainly won't have time to check your facts. At a minimum, you should read a quality newspaper every day – all of it, cover to cover, supplements included. The art that you're reviewing will also have a specialist press and, of course, you should read that too.

The artists whose work you review will not lack ambition and the day will come when you have to evaluate a work of global scope and importance. A well-informed reviewer will be able to bring to the task the apparently effortless authority of the *Wall Street Journal*'s Joe Morgenstern, whose review of Michael Moore's *Fahrenheit 9/11* appeared in the year his criticism won the Pulitzer Prize.

At one point in the course of Michael Moore's rambling, troubling and sometimes rousing 'Fahrenheit 9/11,' I recalled a remark that the media-savvy satirist Harry Shearer made years ago about the newspapers of the time in San Francisco. Reading them, he said, was 'like getting your news from the crazy lady in the Laundromat'. Well, watching Mr. Moore's film means getting your news from the media village's most famous or infamous bomb-thrower, self-promoter, used-theory salesman, glib falsifier, discomfiting truth-teller, aggrieved patriot, shrewd lampooner, serial ambusher and, in his latest feature-length polemic, Bush-beater with a seething vengeance.

In the next paragraph, Morgenstern marshals the allegations that the film makes about the President's oil interests. He then evaluates some of the recycled news clips in the movie. He is clearly familiar, if not severely bored, with all of them but the recitation makes it possible for him to fill in any gaps in his readers' knowledge while demonstrating his own authority.

Morgenstern goes on to evaluate the likely impact of the film on the presidential election campaign that was due to begin that year. Balancing his positive and negative reactions, he notes that the scenes featuring the victims of the war in Iraq did much to redress the balance in the media coverage at that time, and judges that the sequences which show the army's recruitment strategy apparently focused on poor and deprived communities is also a valuable correction to the consensus. Finally, he concludes:

> The movie's title is a reference, made in spite of the author's objection, to Ray Bradbury's 'Fahrenheit 451,' a classic sci-fi novel set in a future when firemen burn books and libraries in a ceaseless campaign to suppress independent thought. Michael Moore isn't that kind of fireman, but he's certainly the arsonist auteur of an incendiary feature that has already won the top prize at this year's Cannes Film Festival; caused a rift between two American studios (Disney, which financed it, then disavowed it, and the company's Miramax subsidiary, which had planned to distribute it); captured the imaginations of lots of moviegoers in advance of today's opening, and will debut on DVD before the November election. Fahrenheit 451, by the way, is the kindling point of paper. For better and worse, 'Fahrenheit 9/11' is a new kindling point for film.[7]

Knowing your Territory

By definition, a reviewer has expert knowledge. Many reviewers come to the profession after a significant amount of study. No less than three of the eleven top drama critics in London have doctorates, as

does film reviewer Mark Kermode who continues his academic inter-
est in cinema as a Fellow of the English and Film Department of
Southampton University.

Some reviewers bring half a lifetime of professional expertise to
their work. While some reviewers become practitioners, probably just
as many practitioners become reviewers. Here is the legendary rock
critic Robert Christgau writing of one of his colleagues who came to
reviewing after being both a musician and a producer.

> (Jon) Landau was one of the first rock critics, working at the begin-
> ning for *Crawdaddy!* and then moving on to *Rolling Stone*. He writes
> as a record producer and ex-musician. As an analyst of the guts
> (or machinery) of rock and roll he has no peer. This can be very
> useful. It's nice to go back to a record you've enjoyed casually and
> understand how a drum break or stereo separation that Landau
> noticed makes it work; and even though technical expertise isn't
> necessary to such insight – musical illiterates like (leading critics)
> Greil Marcus and Lester Bangs make them all the time – it certainly
> helps. And only a critic like Landau can observe authoritatively that,
> for instance, the Motown sound depends on sophisticated chord
> changes and a 'relentless four-beat drum pattern'. He is especially
> acute when he applies both kinds of analysis to music he really
> knows and loves, as in his definitive piece on Wilson Pickett.'[8]

Christgau goes on to note that Landau's expertise alone was enough
to build his reputation. His writing, he says, moved up from 'club-
footed to pedestrian' but if it lacked skill or style it was never short
of insight.

Many reviewers are not so well grounded. One of the all-time
greats, Pauline Kael, famously mis-attributed responsibility for the
script of *Citizen Kane*, but at a time when her eminence was beyond
question. Most of us would not survive such a spectacular mistake.
It is well said of journalists that, while they may not know, they know
where to find out. Unless you're a last-minute substitute reviewer sent

out into the field without time to do more than grab a pen on your way out of the office, you should find out as much as you can about the work you're reviewing and the people who created it. You should also be able to set that work in the context of the development of the art as a whole, and be aware of the major issues at work in it. Here is Philip French, writing in the *Observer*, about the first of the Pirates trilogy, *Pirates of the Caribbean: The Curse of the Black Pearl*.

> The pirate movie is a sub-genre of the swashbuckler and its first classic came before audiences could hear the swash – the 1926 silent movie *The Black Pirate* starring Douglas Fairbanks Sr, most graceful and spirited of action stars.
>
> A key ingredient peculiar to the pirate movie, experienced through the spectator's imagination, is the tang of salt air and the sea breeze in one's face as the Jolly Roger is unfurled, the sails billow and we embark for the Spanish Main. It is a childhood feeling of freedom, fraternity and irresponsibility.
>
> There have been surprisingly few truly first-rate pirate movies since *The Black Pirate*. The best came in the Thirties and Forties – Errol Flynn in *Captain Blood and The Sea Hawk*, and Tyrone Power in *The Black Swan*, and a couple of versions of *Treasure Island*. And there's been little since Burt Lancaster's tongue-in-cheek *The Crimson Pirate*, made in 1952.
>
> Recently, there has been a string of critical and box-office disasters as bleak as those grinning skeletons stretched out beside empty treasure chests on desert islands: *The Island* (1980), which cost Michael Ritchie the chance to direct *The Right Stuff*; Peter Cook and Graham Chapman's sad spoof, *Yellowbeard* (1983), *Pirates* (1986), which introduced a 15-year drought for Polanski; and *CutThroat Island* (1998), which damaged the careers and marriage of its director, Renny Harlin, and star, Geena Davies. Talk about a curse.[9]

If you have taken my earlier point about appropriate writing, you will understand that this level of erudition is perfect for an upmarket Sun-

day arts supplement, but the movie page of a teen magazine would probably be happy just to tell readers that the movie is based on a Disney theme-park ride and to namecheck the brand of Johnny Depp's eyeliner.

So, where to find the information you want? If you are attending a press event and the publicist in charge is experienced and responsible, much of the information you need about the work in question will be in the press release. Check it after the performance, because publicists often see no need to record the name of an artist or technician who is less than a headliner. An emergency smattering can also be picked up quickly from the Web, although you need to evaluate online information carefully. The fact that the author of website text can be impossible to trace means that there's a vast quantity of junk out there. Wikipedia, for example, will often be the first name thrown up by an Internet search, but, as you are probably aware, Wikipedia has been sued by people about whom it has recorded damaging and incorrect information. So make it a rule always to read beyond Wikipedia.

In addition to immediate sources of information, you need background knowledge from the literature about your field. Here's how that works.

Visual Arts

Obviously you should know the artist's previous work, the movement to which it belongs, the other artists considered to be part of that movement and the background of the galleries or collectors who are exhibiting the work. You should know where the artist trained, if she or he was taught by another artist of note and if she or he has defined a philosophy or ambition. If the work has won an award, you should know the significant facts about the judges and the previous winners, also the prize's sponsor and its history. You should be able to appreciate the technical demands of the artist's chosen medium.

Theatre, Film or Television

These are all collaborative media so you need to be aware of the backgrounds of all the major players. In serious publications, the director is the most important person in the process but for fan-oriented or popular mainstream media the leading actors take precedence. The cinematographer, art director, designer and editor are also significant. As a writer yourself, you'll want to give the playwright or screenwriter due prominence. So you should be able to go right down the credits and know what each name has done before and, if possible, what they're doing next. For the writer, director and cinematographer, knowing what their influences are is also important. Then you need to know the major works in the same genre, the agenda of the producer or commissioning network. For a film, how the production was financed can be important, and for any screen drama you should know where it was made – that way, you won't praise the use of the moody sequences In the back streets of Paris when the production was shot in Prague.

If you're reviewing a classic play, you should know its performance history, be able to identify important elements in the drama and refer to major previous performances in the leading roles. So if you were reviewing *Henry V* by William Shakespeare, you should be aware that this is the fourth of Shakespeare's seven history plays and that the character of the King first appears as a wild youth in *Henry IV Parts I and II*. It dates from 1559, is said to be the first play ever performed in the new Globe Theatre and the most famous piece of the text is King Henry's St Crispin's Day speech which has been quoted in *Star Trek*, *X-Men II* and many other works.

Reference works for classic theatre are on the whole authoritative and reliable. In cinema there are certain much-admired standards and institutions such as the British Film Institute who commission essays from authoritative writers. There are magnificent directories of film and filmmakers, like that pioneered by Leslie Halliwell. There is also a vast amount of geeky, pointless and self-indulgent film writing which you

can safely ignore and which you should try not to enlarge yourself.

Television, in contrast, hasn't nearly enough in the way of either archives or high-quality commentary, but then the industry as a whole has a goldfish attention span so if you lack knowledge you will have that in common with many practitioners.

Classical Music, Opera and Ballet

These again are collaborative performances so the list is a long one, with the conductor, the director and the leading performers at the top. You should know not only their professional history but also their relationship with the composer, of whose work they may be noted interpreters. In opera and ballet, the director is equally important and in most cases there will be one designer for both sets and costumes who may also be of significant stature.

In music and opera, the composer is the central figure in the work and a high proportion of performances are of work whose creators are no longer living. You need to know where the work belongs in the composer's development – was it an early experiment or something from the height of his career? The work itself has a performance history; I've always enjoyed noting that Tchaikovsky's *Swan Lake*, now considered the apogee of nineteenth-century classical ballet, was a resounding flop on its first outing at the Bolshoi. These works also have well-defined highlights – the famous aria or pas de deux – and a knowledgeable reviewer should be able to put forward an opinion on the execution of these challenges and compare the current interpretation with the work of other interpreters in earlier productions. Fortunately there is a substantial body of authoritative reference literature to help you.

Popular Music

There are a zillion subcultures in popular music and if you're reviewing something that belongs to one of them you won't need this book

to tell you what to call it. You should know the music of the major names in the field and the artist's previous work. You should probably also be aware of any celebrity or industry gossip surrounding the performers and, if you're reviewing a live event, you should know the latest albums from the performers and be able to compare the live performance with the recordings.

Books

Curiously, the author's background and ambitions are valued less highly in reviewing literature. Very few writers manage to achieve long careers; many more are published a few times and then dropped. With about 2,000 new novels being published every year, literary editors struggle to select those worthy of attention. Non-fiction books are easier to evaluate and to align with a standard news agenda, so they tend to dominate review space.

There are significant differences in reviewing fiction – novels and short stories – and non-fiction, which can include works of history, biography, social commentary or travel writing. Non-fiction tends to belong to a clearly defined field of expertise. In reviewing it, you need a background knowledge of the subject and the dominant works on it. If this is a biography of John F Kennedy, for example, you should be familiar with the history of his time and with the most highly regarded works on his life. Major media will give a book about such a figure to a prominent historian or politician, beside whose review a simple evaluation based upon the reading experience will appear naïve.

When reviewing fiction, it is more important to understand where the book and the author fit into the great panorama of modern writing. While the author's antecedents are important, and a critical analysis of the work is expected in the quality press, the reading experience is also central to your response to the book. If it is in a recognisable genre you should know the work of authors who have defined it, but the concept of genre in literature is becoming increasingly elastic

as more and more books defy classification. A grounding in literary theory is helpful, as is an understanding of basic narratology. Personally, as a novelist, I know that theory is rarely relevant to the practice of writing and I view narratology as a misguided pseudo-discipline but when you are struggling to analyse your response to a work it can be helpful to separate it into elements – character, setting, storytelling, suspense, language – and judge how well the writer has addressed each of these.

A new reviewer may have the experience of feeling frustrated or confused by a novel but not knowing why or what to say in response. If you ask yourself how the writer has defined the characters, for example, you may find that there's no visual description, so the reader cannot form a picture of the main players. Or if you think analytically about the narrative, you may realise that the author has set up a suspenseful sequence of events but instead of delivering on the tension thus created has chosen to break the flow and create a surprise *denouement* – a strategy guaranteed to make the reader feel angry and cheated and known to theorists as the *deus ex machina* resolution.

To make your life as a reviewer easier, we have included research checklists for these fields at the back of this book.

MAKING NOTES

While experienced critics hold a lifetime of knowledge in their heads, a newbie may make notes in advance, particularly when there will be little time to write the review itself. When you're filing copy from an event, keep your notes as short as you can – there won't be time to trawl through them looking for a keynote fact before you finish writing.

It shouldn't need saying, but whatever kind of writer you are, you should always have a notebook with you, and you should certainly make sure that you have a note-making device and a backup plan when you set out to review a work.

3. STARTING TO WRITE

You may feel that many of the things I'm about to say should not need saying, and you will be right. They are simply the essential principles of good journalism applied to the task of writing a review and as such should be a given for any writer intending to create a career in the media. I wish I could say that I have never seen any of these rules ignored, but I can't.

Journalists, some of them quite distinguished, can behave with an extraordinary lack of professionalism when asked to write an arts review. Perhaps they're acting from the sense that their subject is trivial beside the great affairs of the media; no war ever broke out because of an arts review, no government fell, no great political movement started. Often negligence will only be noticed by the artists themselves and, hey (figures the irresponsible writer), who cares what an artist thinks, anyway?

So I have been in a screening room with a very grand colleague who fell asleep the moment the movie's title appeared on the screen and only woke up when we nudged him as the closing credits rolled. He went away and wrote a highly critical, and, of course, highly misleading, review of the film, despite the fact that he hadn't viewed a single frame of it.

I've been in theatres next to the empty seat reserved for a reviewer with a drink habit who spent the performance in the bar but at least

had the grace to heap lavish praise on the play he hadn't seen. And I've certainly read reviews of my own books written by critics who clearly hadn't read them. My favourite was a critic in an Irish newspaper who reviewed my very first proper work as an author, a study of celebrity culture based on my years of interviewing the famous. 'Cynthia Brayfield seeks to persuade us that every celebrity has a fake identity imposed on them and is stalked by a fictitious *doppelganger* made up of society's expectations,' he sneered. Given that my name is Celia, not Cynthia, he'd pretty much proved my point even as he tried to rubbish it.

As for note taking, well, as a young reviewer with excellent Pitman's shorthand, that was my job. I took the notes and my colleagues, whose shorthand was slower or non-existent, sat back and enjoyed the shows then asked me to read them back the bits they needed in the bar afterwards. All that stuff about camaraderie in the press corps – it's all true. They paid me back at the press conferences in which they asked the questions that I cringed at, the 'How big was the budget?' and the 'Were you shagging your co-star?' questions that I suspect nobody can get past their tonsils unless they've done decades of deadly hackwork and are only hanging in there for the pension.

So many of these rules are occasionally honoured in the breach but as they are the essential principles of good practice you should at least set out to observe them with goodwill and enthusiasm. Professionalism is a subset of virtue, something to maintain for your own sense of integrity, whether you're being observed or not. If you want to like what you see when you look in the mirror every morning, be professional.

If you're a scuba diver you check your air before you get in the water, if you're a surgeon you observe sterile procedures before entering an operating theatre and if you're a journalist you make notes and check facts. Like good practice in any other field, professionalism is a good habit that you strengthen every time you use it and weaken every time you let it lapse. You can bet that if you get sloppy you

will surely be caught out one day. Conversely, if you maintain a high standard of work, no matter how lowly and seemingly irrelevant your assignment, it will be noticed. Your employers will value you for it and, even more importantly, so will the professional contacts you make in the artistic community.

The arts are an unforgiving work environment. Competition is ferocious because so many people want to live in these golden worlds. Creative industries may appear disorganised, but they are not, and they do not tolerate practitioners who cannot maintain high standards. An actor who is late for auditions will not work, nor will an assistant editor who gets lazy about labelling rushes or a musician who doesn't practice every day. The people who rise to the top in these industries respect fellow professionals but despise the slack or the idle. If those faults occur in people who are, in addition, arrogant and irresponsible in positions of influence, they tend to produce very short careers.

MAKING NOTES

This can be more demanding than you imagine at first. If you're reviewing a book, you can sit sedately at your desk and rattle your keyboard or scribble on a notepad: it's easy. If you're at any kind of performance or screening, you'll need a notebook of optimal size, two pens (in case one malfunctions) and a way of writing fast. You may aspire to the honour of being the first to quote one of the great lines in modern drama, a line that'll be up there with John Travolta's insistent, 'Would you mind not shooting at the thermonuclear weapons?' in *Broken Arrow* or Frances McDormand's deadpan observation in *Fargo*: 'And I guess that was your accomplice in the wood chipper.' You won't make it if you haven't written down the words. Reviewing is a branch of journalism in which shorthand isn't essential, but it's useful and in many situations it will give you the edge on your competition.

Notebooks I have known and never bought again. The A4 student pad is too big, the Moleskine pocket-sized jotter, as allegedly used

by Ernest Hemingway, is a thoughtful Christmas present but way too small. A5 is about right, and an A5 spiral-bound reporter's notebook is the best tool for the job. The spiral binding allows you to whip pages over very fast and never lose your place. If you're a shorthand writer, you'll need ruled lines.

Fancy technology is not of great use in reviewing. At press shows, the lights in cinemas or theatres are sometimes only half-dimmed to allow note taking. Some old-style, custom-built preview theatres even have a strip of spotlights down the outer aisles, as well as plush seating more suitable for airline first-class cabins complete with footrests and integral cocktail trays. Pity they never became industry standards. In the absence of such facilities, many reviewers either scrawl illegible notes by the glow from the stage or screen or they use penlights or pencil torches; trying to go one better and turning up with a spotlight strapped to your headband won't make you popular because the beam distracts your colleagues and anyway you'll look like a complete prat.

Digital recorders are invaluable in interviews to give a full record of the encounter and every word that was said. Always make notes as well as a recording; I still shiver at the memory of coming home from an interview with the legendary leading editor of his day, Harold Evans of the *Sunday Times*, who I desperately hoped would recognise my genius and offer me a job. When I turned on my recorder to transcribe his golden words, there was nothing. Silence. Maybe a slight hiss. It took only one more disaster for me to realise that, carrying the recorder in a shiny new hire-me-now briefcase on a very cold day in January, the battery had been chilled to inertia. (I covered by using the few words of scrawled notes I had and being wildly flattering. Evans rang up my editor to thank her but never did offer me a job.)

In reviewing, recorders are a waste of time. You end up with a whole-work recording that you'll have to scroll through laboriously to find the words you want. By all means make such a record if you're anxious about missing stuff, but be aware that recorders will arouse understandable fears of piracy in the organisers of many screenings

or performances and may get you barred for life by the more paranoid publicists.

Equally dangerous are keyboard devices that will rattle as you type on them, such as laptops or organisers; use these and your colleagues will lynch you, sooner rather than later. Recordings by phone or notes on a Blackberry are better than nothing, but only just. So is scribbling on the blank side of the press release. As you are likely to be collecting such literature, it makes sense to acquire whatever kind of bag you feel comfortable with to carry the entire kit in safety: Vuitton briefcase, army surplus backpack, something minimal from Muji – carry your stuff in a biodegradable Wal-Mart bag if you want to make an eco-statement but I must warn you that those bio bags start to rot down from the first second you own them.

READ, WATCH OR LISTEN TO THE WHOLE WORK

This is good practice, good manners and good sense. It can also be a hard rule to keep when you're stuck in a truly dire performance, crammed into a backside-numbing seat and aware that the space allotted to your notice will contain 200 words at the most, just enough to mention the main players and sketch the plot. In such situations, reviewing from the bar seems an attractive option and all around you many of your colleagues will be voting with their feet on this issue.

Stay put. Because he confessed in print, the entire world of theatre in the UK knows that Toby Young of The Spectator left the press night of The Pillowman by Martin McDonagh at the National Theatre at the interval. He said that he had every right to be as bored as an average punter. Veteran critic Michael Coveney disagreed. 'The quality of Young's boredom may be interesting to his readers but is surely an inadequate, not to say impertinent, response to the work of a leading young dramatist ... McDonagh is trying to push some envelope of extremity in the theatre and the critics have to work out whether or not it should remain sealed.'[10] That's how to look like a fool in one easy lesson.

You can hope (against hope, sometimes, it must be said) that things will improve, or that a luminous performance in a small part in the third act will give you something positive to note. You should take a long view of your reviewing career, and understand that a reputation for commitment and fair dealing is a good thing to have. You should reflect that, if you're going to write a negative review, your victims may well complain, in which case your professional practice will have to stand scrutiny and you will be in a weak position from which to defend yourself if you ran out on half the event.

Try not to forget that you're reviewing an entire work and that the artist who created it quite probably contrived some reverses of audience expectation towards the end. Particularly in narrative works, the major effects are often saved for the climax of the piece and you will not only cheat your readers if you haven't gone there, you will risk looking exceedingly stupid if you miss a major element of the drama. Dire as the piece is at the beginning, it may be even worse at the end and bearing witness to that is your job.

Finally, there is the fact that life does not respect art and that a *force majeure* can sometimes make cutting and running a serious mistake. The possibility was hilariously explored in *Only Two Can Play*, a classic British film comedy based on a novel by Kingsley Amis, who drew on his own experiences as a cub reporter. Peter Sellers played a reviewer for a tiny local paper in Wales, who sets off to see a performance by an amateur dramatic society but leaves after the first act to start an adulterous affair with Mai Zetterling, in the role of the glamorous, amorous blonde who was an essential motif in many 1960s comedies. He covered his tracks by filing an approving review of the play, but after he left the theatre a fire broke out and the building burned down. His editor, understandably, felt he'd missed the big story.

TRUST YOUR GUT

After all this preparation, your next challenge is to let go of it all as you approach the work you are going to review. You are part of the

work's audience – a privileged part, it's true, but your response as a simple spectator is the basis on which you will present that work to your readers. Open your emotions to the artist and let them go to work. An academic analysis would describe the feelings you have as the 'pre-critical response' to the work.

Honouring your gut reaction allows you to keep faith with the artist whose work you are reviewing and with your audience. If you set aside your specialist knowledge and your analytical framework, you will experience the work as the artist intends her or his audience to do and that is the only honest approach open to a reviewer. Later, when you have started writing, you can re-engage your intellectual faculties and decide whether the song was derivative, the play formulaic or the movie heavily scarred by the brutal application of three-act structure. You should be able to discuss such questions and at the same time know if you were frightened or offended or moved to tears – because a flawed work can do all those things. Great critics retain the ability to be moved to the end of their careers. Andrew Collins put his mission statement on the top of his web-page, 'Never Knowingly Underwhelmed'. The day you don't come out of *Oklahoma* humming 'Oh What A Beautiful Morning' or leave a Lou Reed concert wanting to kill somebody is probably the day you should find a new job

Clive Barnes, who, when he reviewed theatre for *The New York Times*, was nicknamed The Butcher of Broadway and was famous for being able to close a show instantly with one bad review, was in fact far more likely to rave than rant. One of his greatest notices was this paean of praise to the musical *A Chorus Line*. Much as he loved it, he did not suspend all judgement and his review takes note of shortcomings of the genre as well as the performers.

The conservative word for *A Chorus Line* might be tremendous, or perhaps terrific, he began. We have for years been hearing about innovative musicals; now Mr. Bennett has really innovated one ... It is easy to see from where *A Chorus Line* evolved. It is in direct

succession to Harold Prince's *Company*, and, to a lesser extent, *Cabaret* and *Follies*. The debt is unmistakable, but it has been paid in full. What makes *A Chorus Line* so devastatingly effective is its honesty of subject matter-so that even its faults can work for it.

What followed was a torrent of enthusiastic praise for the "*coruscatingly cruel*" observation, the brilliant writing, the *marvellous* concept. He allowed the sentimentality on the grounds that this is showbiz and the less credible parts of the plot because they're presented as naked hokum. He liked the music although the composer has done better in earlier works, and called the cast *105 per cent marvelous*, with namechecks for the outstanding performers. His readers could have been in no doubt that this was a man bowled over, swept away and totally ravished. He concluded:

> Honesty is the policy of Mr. Bennett's show, and from opening to the stupendous closing chorus, it is, stamped indelibly, as Mr. Bennett's show.
>
> His choreography and direction burn up superlatives as if they were inflammable. In no way could it have been better done.
>
> It is in a small theater and here, at last, is the intimate big musical. Everything is made to work. The groupings are always faultless, the dances have the right Broadway surge, and two numbers, the mirror-dance for Miss McKechnie and the Busby Berkeley-inspired finale deserve to become classics of musical staging. And talking of classics, while there will be some to find fault, perhaps with a certain reason, with the hard-edged glossiness of *A Chorus Line*, it is a show that must dance, jog and whirl its way into the history of the musical theater. *Oklahoma!* it isn't, but no one with strength to get to the box office should willingly miss it. You will talk about it for weeks. (985)[11]

The best reason to be passionate about what you're reviewing is that readers will love you for it. There is no joy to be found in reading a measured, thoughtful, well-informed account of something that is

fundamentally an experience. Nobody opens a critic's page and wants to be talked at by a robot. A vital part of the reviewer's role is simply to be human and so validate the human responses of the people who read the review. At their best, reviewers are like friends who're always up ahead with the cool stuff and bursting to share their enthusiasm.

After the preceding pile of imperatives implying a deliberate, intentional, pre-thought approach to the task of reviewing, you may feel that this is a painful change of gear. How can you suddenly switch from a cerebral to an instinctive approach to the role? How can you make yourself feel your feelings if you've got to the point where your emotions are just a blob of greyish sensation out of sight somewhere beneath a great shiny pile of information? It is a radical change of mode but practice makes it easier.

4. THE WRITING PROCESS

So now you have a raft of research, several pages of notes and your emotional response to the work. And you have a deadline, so it's time to go to work.

The basic structure of a review is not so different from the structure of an essay: introduction, argument, conclusion. What is different is that a review needs to be a vivid experience for a reader. The reasoned tone of a good essay isn't what's needed here. From the moment the reader's attention is caught by the first sentence, the review should sweep them away like a fast-flowing river until they finish the last paragraph feeling happy and slightly overwhelmed. Great journalism is as exhilarating as white-water rafting.

Every piece of journalism has an argument, even those written as objective reporting. A reviewer is expected to be highly subjective, to present an argument that is acutely individual. At the same time, however, a reviewer has responsibilities to editors, readers and artists. How, among all these conflicting demands, is a person supposed to define a lucid and compelling point of view?

Sometimes constructing an argument can feel like arranging a bouquet of flowers blindfold. Judging how one thought relates to the next, how one issue should stand in relation to another, and how to make the whole thing flow seems impossible when you are overwhelmed by material. Or tired, or in pain – I once had to write a really important

movie review in agony after a minor operation at a clinic that had run out of analgesics. The pain was so strong I felt as if I could hardly see the screen, let alone my own words on a page. That movie turns up regularly on lists of the 100 greatest of all time, but I never can quite see what its appeal is supposed to be.

The writing process can be broken down into five principal phases.

ORGANISING YOUR IDEAS

As you go through the process week-in, week-out for a few months, organising your thoughts gets easier and easier. Finally you find your-self doing it without thinking, whatever the circumstances. However, when you are beginning, it can help to make yourself a menu of is-sues and then choose the ones you want to use and, finally, put them in order. Pick out all the main topics that you would like to include, thinking about your own response, the information your readers need and the news agenda of your publication, and note them down on a blank page.

Suppose you were reviewing the film *Blood Diamond*, which starred Leonardo DiCaprio as a Zimbabwean mercenary trading arms for dia-monds in the civil war in Sierra Leone in the 1990s.

Your menu could contain:

DiCaprio/Performance as villain. Zimbabwean accent
Oscar nominations/ Caprio/Djimoun Hounsou
War in Sierra Leone
Seriously violent – I had to look away
Hollywood's history in Africa
Conscience thrillers – new genre?
Producer/director Edward Zwick – return to political cinema after
 The Last Samurai?
Supporting cast, Jennifer Connolly/Djimoun Hounsou
Locations – South Africa, Mozambique
Disabled child actors – crew set up charitable fund

What is a blood diamond – definition
Trade today – Kimberley Process/De Beers

INTRODUCTION – DEFINE YOUR ARGUMENT

Your argument will be the skeleton on which all the colour and energy
of your review is anchored. You should state it arrestingly in your first
paragraph, develop it in the body of the notice and finally use it as a
springboard for your conclusion. So when you have defined your argu-
ment your review will almost write itself.

When you've got the main points down on paper, make your choice
of Lord Beaverbrook's 'best strawberry'. Looking at your menu, which
of these topics should you lead with? Which is going to seize the at-
tention of your readers most effectively? Once you've picked your lead
topic, the rest of the argument should arrange itself logically.

The choice of best strawberry depends on the news values of your
publication. If you were reviewing for an upmarket arts supplement
you might arrange that material like this:

1. What is a blood diamond – definition
2. War in Sierra Leone
3. Seriously violent – I had to look away
4. Conscience thrillers – new genre?
5. Producer/director Edward Zwick – return to political cinema after
 The Last Samurai?
6. Oscar nominations/Caprio/Djimoun Hounsou
7. DiCaprio/Performance as villain. Zimbabwean accent
8. Supporting cast, Jennifer Connolly/Djimoun Hounsou
9. Locations – South Africa, Mozambique
10. Trade today - Kimberley Process/De Beers
11. Hollywood's history in Africa

If you were reviewing for a lad's mag and your notice was due to ap-
pear between the article on how to get a six-pack gut in two weeks

and a picture of a young woman in less than requisite attire, you would probably have less space and your agenda would look more like this:

1. Supporting cast, Jennifer Connolly/Djimoun Hounsou
2. Di Caprio/Performance as villain. Zimbabwean accent
3. Seriously violent – I had to look away
4. Oscar nominations/ Caprio/Djimoun Hounsou
5. What is a blood diamond – definition
6. War in Sierra Leone
7. Disabled child actors – crew set up charitable fund
8. Trade today, Kimberley Process/De Beers

There is a convention in reviewing that the first paragraph should not contain the word 'I'. You will notice that many of the great reviewers quoted in this book just didn't know that. What they did know was how to project their authority and at the same time offer their personal response to the work. As long as you do that, you can use any pronoun you like.

If you read the reviews chosen as examples in this book carefully, you will appreciate how many different ways there are to write an intro and how artful critics can be in projecting the essence of their argument in the very first sentence, whether they take a colloquial tone and address the reader as if talking to a friend or a formal approach that states a premise or poses a question.

ARGUMENT – DEVELOPING YOUR THEME

The middle section of a review is usually the most irritating, if not exactly the most difficult, to write. This is the area in which you need to deliver your hard information, the names, dates, titles, credits. You need to do this within the framework of your argument, illustrating your points one by one. You need to create a flowing text that presents wads of plain, ugly information. There is a danger that your piece will collapse in the centre like an under-baked cake.

Whatever the imperatives under which you are writing, it is important to build a logical flow of meaning from one sentence to the next, from one paragraph to the next. Coherence can be very hard to achieve when you have a mass of facts, names and issues to assemble but the better the structure of your argument the easier your review will be to read. It will also be more impressive; your argument will seem convincing, even irrefutable, and your authority will seem greater because of that.

A technique you can use to keep your writing light and sparkling through the middle of your review is to use the most emotive words you can. Why say you 'liked' something if you can say that you 'loved', 'adored' or 'worshipped' it? Why stick with 'dull' when you can use 'dismal', 'dreary', 'tedious', 'dry', 'lumpen', 'mind-numbing', 'anaesthetic', 'soporific' or any one of a repertoire of gutsy metaphors or similes?

CONCLUSION – LOOK FORWARDS

A good conclusion should be the resounding extension of your argument. It can simply summarise the text above it, or it can look forward to the future development of the art in question and state the implications of the work under consideration. Yes, it's hard to do this without sounding pompous but bear in mind that you ARE an authority and it's your job to be pompous when the occasion demands it.

If you're female, take this point to heart. Somewhere on the X chromosome there's a gene for creating harmony and not rocking the boat. When you are a reviewer, you need to inhibit that tendency and realise that stirring up controversy comes with the territory. Stop making nice. Stop pleasing people. Stop thinking that what you think isn't as important as what other people think, or that it's your job to make everyone happy. Yes, people may call you names – look how mean they are about Dorothy Parker. Name-calling is not the worst thing that can happen. You may feel wounded if people start dubbing

you bitch, scissor-lady or Little Miss Vitriol, but you'll feel even worse if you lose your job to a reviewer with a Y chromosome and no inhibitions about expressing his opinions.

Once you are confident in your authority, writing a conclusion becomes easier. Getting that conclusion into print, however, requires low cunning and an appreciation of the production process. You will probably have been given a word-count for your notice. If your copy needs to be cut, an editor in a hurry may simply chop off the last paragraph since – they reason – there's no important information in it anyway. So your elegantly concluded review is transformed into a mess of an argument that goes nowhere.

Avoiding this fate is simple. You can write short. Not very short – 50 words less than you're asked for should do it. Or you can mark possible cuts in the text by writing (poss cut) and (end poss cut) at the beginning and end of the less essential passage somewhere in the middle of the piece. You can also take the Mozart symphony approach and write false endings, but that takes time and wastes words.

DIFFERENT MEDIA

This description of the writing process assumes that you're reviewing for a print publication of some kind, and that you have upwards of 500 words to play with. While organising your ideas is a good discipline however you are to communicate with your audience, you will need to adapt your technique to the special natures of other media.

The golden rule is to consume the medium for which you're working. Read the magazine, browse the website, watch the programme, not just once or twice but as often as you can before writing. Note the typical word counts or the length of reviews, the questioning style of the chairman, if there is one, or the approach of other writers on the same page or in the same publication. You cannot appear at your best if you have prepared a ten-minute notice for a three-minute slot and your interviewer cuts you short, or if an exasperated editor has

to track you down half an hour before the edition deadline to ask for another 300 words.

Print on the Page

You will almost certainly be working to a set word-count. Below the 500-word mark, you will need to balance the essential information about the work with the need to be arresting and entertaining. Keep the facts to the minimum and ransack your vocabulary for colourful language.

Print On-line

You may be offered an unlimited word-count, which is an invitation to waste your time. 1,000 words are usually enough for anyone, but make sure to write in short paragraphs. On-line journalism is similar to writing for a tabloid; the readers' attention span is small and paragraphs just one sentence long are common. If your review is to run over more than one page, remember the premium on 'stickiness' and try to estimate where the page break will fall and build a cliffhanger into the text at that point. If there is time and your colleague is amenable, ask to see a proof of the page to make sure you get it right.

Previews and Star Ratings

In both print and on-line publications, previews, potted reviews and star ratings dominate sections of the media which are more entertainment guides than arts journalism. Websites which collage ratings from other sources, such as www.metacritic.com, are multiplying too. For the writer, the over-riding imperatives are obvious – you have no space, 50 or even 30-word previews are normal; and you have a colossal amount of information to check. The checking may not be your job; many listings are pasted-in directly from material sent out by the

production company or another medium. If it is, you have my admiration and my sympathy, and my hope that you enjoy a horoscope in which Virgo is heavily aspected.

The pressure on space makes previews more challenging to write than reviews. In your early attempts you'll find yourself running out of adjectives fast. My own strategy was to prioritise stuff that readers enjoyed and almost ignore what was of less-than-prime interest. So in TV listings for an evening paper, I had the afternoon programming set in a very small font and ran on the programmes, which gave me a small paragraph of space for each of the primetime shows. Name-checking was restricted to no more than two significant creators of the work. When I listed soap operas, it was obvious that readers had high interest in them but also that they might have missed episodes and so I added a catch-up sentence. Stealing space from items of less interest in order to be able to write something sparky about the prime events eventually meant that the preview column was more about highlighting good stuff than panning bad, which is a route most editors now take. I redesigned the page to give a 'pick of the day' more prominence. I found that emotions, even if reduced to one exclamation – like gr-r-r-eat! – could work in a small space.

Star ratings are the ultimate space-saver and they save time for readers too. Artists hate them, gatekeepers check them nervously. They're not subtle and they trivialise serious work, so they're rare in the quality press. You don't have to use stars – some previewers use thumbs-up signs, smiley faces or other icons; readers know what you mean. Five stars good, one star bad. Three stars, reviewer can't decide or they're out-of-depth and playing safe.

The distinguished rock critic Robert Christgau is the king of the haiku review and also often credited with introducing star ratings for the albums he featured. His *Consumer Guide* columns, which started in *Village Voice* in 1969 and now appear on MSN Music, comprise up to 20 one-paragraph album reviews, each of which has a letter grade ranging from A+ to E-. Over time, he weighted the column more to-

wards music he liked better, although the week before Thanksgiving he used to run a 'Turkey Shoot' collection of reviews of albums graded lower than a B-. Despite their brevity, his notices have been praised as 'dense with ideas, allusions, first-person confessions, invective, highbrow references and slang'.

Radio

The bliss of reviewing for radio is that you can use notes and refer to them shamelessly, unseen by your audience. This you cannot do on TV. Some radio reviewers write themselves entire scripts. Some programmes even demand that you do this. If you can, however, you should work from headline notes or bullet points and try to talk animatedly but naturally. Keep your notes to one page; handwrite clearly or choose a font you can read easily. In addition to what you want to say, write down the principal names and facts about the work so that if you have to field a random question the information will be right there under your eyes.

Radio shows can be live or recorded. Live shows always have more energy and pzazz. If you're being recorded, don't let the pace relax too much. While it will be possible for the producer to cut what you say and tailor it to the programme, they will appreciate not having to do too much work on your contribution so keep it bright and sharp. The programme-maker will always want to record more material than they need, however, so be prepared to cover more ground than the final format of the show requires. I once passed an exhausting six-and-a-half hours walking over the Cornish cliffs talking about Daphne du Maurier in order to give the interviewer enough material for a nine-minute radio feature.

The content of a broadcast notice, whether radio or TV, is very much less than a print review. Try timing yourself talking from your notes. This will also allow you to check difficult pronunciation – Kieslowski: it's easy really. Think about your response to the work and identify the

two main points you want to make about it. Then, if you can, discuss these with the producer or presenter of the programme – they will often want to do this before you go on air anyway.

With this agenda agreed, work hard to devise the wittiest way to make your points but be aware also that on radio a listener can miss the sense of a throwaway remark. So pack a few words of verbal polystyrene around your polished *bon mot* to prepare the listener's ear for it.

Once you are in the studio take care of anything that might create noise. Turn off your phone. If you have more than one page of notes, try to arrange them so you can see them without shuffling papers near the microphone – on air that sounds as if there's a hurricane raging through the studio. If you are wearing a clunky bracelet or earrings that tinkle like tiny bells, take them off. If you use a hearing aid, it may well create ear-splitting feedback so ask the engineer or studio director if you need to leave it outside the studio. These precautions also hold good if you're reviewing from a location; if you choose the place, be aware that the noise created by overhead planes, distant tractors, a brisk wind, PA announcements or even laughing children in a playground nearby will all sound bizarre if they are the background to your voice.

An obvious point, but one easy to forget in the hysteria of a live studio, is that your audience can't see what you're talking about. It may not be clear, for example, whether the character in a performance that you're discussing is black or white, male or female. If it is essential that your audience have visual information, make sure you cover it in your notice.

Television

Always watch the programme before you appear on it. This not only helps you but it is a keynote of professional behaviour in the industry. TV may be talking wallpaper to you but to the people who work in it it

is meat, drink and the breath of life itself. If you can't see the show – maybe you've just arrived in the city and it's a local programme – ask whoever hires you if you can download a clip or if they can send you a DVD of recent broadcasts.

Find out if you can use notes – chatty, on-the-sofa morning TV isn't very note friendly but news-style programmes are easy with contributors who bring a page of notes on set. Many studio directors prefer performers not to wear glasses in case they catch the studio lights and reflect them, so make sure you can read your notes with your bare eyes. And if you can't use notes, take time to learn the essential facts by heart.

Again, it will help you to focus your review if you rehearse the key sentences and time them. If you're taking part in a discussion, whoever chairs or moderates it will probably talk to you before you go on screen and give you an idea of the approach they intend to take. However, there is a small minority of TV anchors who believe that guests on their programme act with more animation if they are not prepared. I've even experienced an interviewer who deliberately misled me before we went on air, expecting me to respond more naturally when he did a Jekyll-and-Hyde transformation on screen and turned from cultured art-lover to tabloid attack dog. Jonathan Ross acted terribly polite at the start of our interview then suddenly attacked with what he imagined was a killer surprise question as the studio manager was telling us to wind-up. Neither of these gentlemen got the result they wanted because their unrehearsed questions were so far off the mark that I couldn't answer them and wasted the last 30 seconds of interview gasping. If you watch a programme closely, you may be able to see if the anchor uses this technique. Sensible researchers often warn programme guests to expect the unexpected; sensible guests can always ask what might lie ahead.

What to wear on television? TV is a battle for the viewers' attention. Men, feel free to wear almost anything you like. There's no imperative to wear a suit; the poet Ian McMillan has made his Hawaiian shirts a

trade-mark. But a lot of men choose suits or dark sweaters. Women appearing on TV with men are at a disadvantage because their voices are light, they don't like to interrupt and their style of talking is less aggressive. The licence to wear bright colours can balance that, but for women there is an iconography on screen; if you wear a neat bright jacket you'll look like a newsreader. You may want to look like a newsreader, so that could be fine. If you want more gravitas, choose a darker colour. If you want to look funkier, go for a neat bright sweater and maybe a bold necklace. Find out what colour the sofa or the studio background is and wear something that will contrast. Don't go for a printed top, however fashionable, because it will act like camouflage, break up your silhouette and reduce your visual impact. Stay away from beige and pastels because they just fade you out.

The jacket may be all you need to worry about. If you've watched the programme, you will know if you need to think about what you're wearing below the waist. Many a news bulletin has been read by an anchor in a hand-made jacket, silk tie and jeans. If you can't see the show before you do it, ask the researcher for advice. If you're seated around a table, or at a desk, only your top half will be seen. If you're sitting on a sofa, you need to think about your whole outfit. Don't even think about shorts, not even in Australia. Are you a woman and is the sofa really low? Trousers are great. If you want to wear a skirt, take a look at how it will be seen by the viewers. Put a chair in front of a full-length mirror and sit on it in the skirt you're considering to make sure it looks as modest as you'd like it to. Do not trust any of the studio team to tell you if you're showing acres of thigh; in the eyes of many TV professionals, the more thigh the better.

It's highly likely that the sound person will want to pin a lapel microphone on you; this is easier if you are wearing something with lapels. If not, the mic may end up on the neck of your T-shirt or on the edge of your décolletage, which can look as if a very small vampire bat has landed. Tiny prints, checks or very narrow stripes can sometimes 'strobe' – meaning blur like a watermark – on camera.

As you will be near, or even wearing, a microphone, all the advice in the radio section about creating wild noise also holds good. Get rid of tinkly jewellery – now you know why Russell Brand prefers large crucifixes. Don't shuffle papers. In addition, don't put your hand on your heart if you're wearing a body mic; all that happens is that you thump the receiver and risk blowing out the crew's ear-drums. So no emotional gestures, please.

5. FINDING THE BALANCE

A reviewer is subject to conflicting forces. The role requires that you find an equilibrium between relationships and responsibilities which all seem equally important. Usually, all the parties involved want different things. Usually, those things also conflict with the reviewer's own ambitions or beliefs. And, usually, the pressure these parties place on the reviewer is pretty strong. So finding the place where you can hold your own ground against forces which often seem overwhelming is the most difficult part of reviewing.

EDITORIAL IMPERATIVES

First of all, there's your editor. All editors want just one thing – a better audience. What kind of audience they want depends on the news agenda and readership but, whatever kind of readership is to be targeted, editors want more of it. More readers, more viewers, more disposable wealth, more opinion-forming clout; just – more.

Why should this be a problem for a reviewer? Don't we all want to be top of the ratings? In principle, yes. But in practice reviewers seldom want the biggest possible audience at any price, which is what some editors need. To that end, they will slap a headline on your review which completely traduces its content or even cut the review down to a caption for a picture of the lead singer/first violin/swan princess in a push-up bra and a low-cut top. This behaviour is universal

in the media, only executed with more hypocrisy and less panache in serious publications. You may even be dealing with a whole bench of sub-editors who have been conditioned like lab rats to dumb down everything that appears on their screen.

Worse, the pursuit of a bigger readership may lead your editor to favour style over substance in your reviews, especially if that style is aggressively negative. Some editors have no respect for thoughtfulness, moderation or social responsibility. They want blood and they want it in words they can blow up to 48point and lead a spread with. You may note, kindly and accurately, that Britpop winner Ruby Slippers sang as if she was in the early stages of an attack of sinusitis; you may know that she really did have sinusitis and told you so before the set; the two of you bonded briefly when you offered her your own packet of Sudafed sinus tablets.

Your editor doesn't care; your editor has a large picture of Ruby looking wasted as she trips over a cable, a snap that was taken on a phone from the audience by some wannabe pap looking for a quick fifty. On a slow news day, your editor is going to storm the front page with that picture, Photoshop-away the cable and run the altered image below a headline announcing RUBY BOMBS AGAIN. Your review will be printed alongside a completely fictitious account of Ruby's battle with her drug habit. Because, in your editor's mind, all rock stars have drug habits, that's their role in their media half-life. When this happens, Ruby will never speak to you again and, more significantly for your future access to award-winning rock stars, neither will her publicist. What you have there is a toxic editor.

If you find yourself in the clutches of a toxic editor, leave the job immediately before they kill your career. The music critic Andrew Porter, whose reviews appeared in the *New Yorker* and the *Financial Times*, then moved to the *Observer* but resigned when they ran his appreciation of Peter Maxwell Davies' sixth symphony under a headline that read: SIXTH APPEAL … NO SOONER IS ONE CLIMAX OVER THAN ANOTHER BEGINS.

Stay with a toxic editor long enough for the world to notice and your name will be tarnished – not forever, because media executives have short memories, but for now. Toxic editors usually have big budgets, so you may have to modify your lifestyle dramatically, but a few months of misery will be better than the life of a media pariah.

Fortunately, outright toxic editors are rare, but editors with toxic tendencies are quite common. They tend to prefer critics who write sparky copy but know nothing. Indeed, I have heard more than one editor say that an ignorant critic is better than an expert because they don't intimidate the readers. 'Increasingly,' wrote Michael Coveney, 'editors are sending in the critical clowns.'[12] The worst editorial concept of the reviewer's role is limited to writing bitchy notices and making them laugh. Such editors are suspicious of reviewers who love their field and have built up good industry contacts, so you may need to curb your enthusiasm in conversation if such a character takes over your section.

Notice the very low opinion of the audience's intelligence in a toxic editor's worldview. Editors are often struggling to relate to an audience demographic which is a long way from their own CV. When a 45-year-old gains dominion over the rock reviews, or a former sports editor is suddenly put in charge of the culture supplement, they have a readership template handed down by the advertising department but no personal identification with the readers they need to capture. Great editors work on instinct; usually they live, breathe and feel exactly as their readers do, but great editors are rare. You will often be ruled by a person who has no secure idea of who your audience is and is making clumsy lunges for the chimera that they believe them to be.

You, on the other hand, may well be your audience – same age, same income, same broken heart, same credit-card debt, same favourite shirt from Gap. So your editor's heavy handed demands for simpler vocabulary and less intellectual weight will, in fact, negate your purpose. Your role here is to know that you are right and negoti-

ate, calmly but relentlessly. Stealth, guile and low cunning will win in the end. If your editor cuts every word over two syllables, write a first paragraph in nursery language and keep the big words for later in the notice. Politics, especially feminist politics, belong from the fifth paragraph onwards – by then the editor will scarcely be reading for sense at all. Conversely, if you know your editor is going over your readers' heads, pitch and begin articles grandly, and move to a simpler style later in the piece.

I'm advocating devious manoeuvres here because, sad to say, I've never found reason a very effective weapon in an internal media conflict. You can weigh in with readership profiles, readers' emails and letters, focus group reports or specially commissioned market research but it is unlikely that any of these will change your editor's concept of the audience. As for getting your editor to admit that he or she was wrong – this is never going to happen.

All creative workplaces are highly emotional and it is very rarely possible to get people to act against their feelings. If the working environment is not only creative but involves tight deadlines, the executives are making intuitive decisions all the time. Information, argument or logic don't have much purchase on their judgement. The only thing that can work is using emotion to fight emotion. At one point in my career, I was doing this about once a month with a whole desk of well-meaning but toxically-trained sub-editors. Asking nicely didn't work, being reasonable didn't work, losing it on selected occasions did work. 'Uh-oh, Celia's doing a Vesuvius,' they said. But then they listened to me.

THE ARTISTS

Decisions about your relationship with an artist are decisions about the boundaries of your integrity as a critic and every individual draws the line in a different place. Cosmo Landesman, film critic of the *Sunday Times*, rarely goes to film festivals and awards ceremonies

because, he says, he hates 'the backslapping, luvvie part of the film business'. The late Harold Schonberg, the *New York Times*' music critic for 20 years, was such a purist that he would refuse to go to a dinner party if a musician was also invited because he believed that it was best for a critic to remain totally detached from the artist and have no personal knowledge of them.

The *Guardian* newspaper recently launched a blog discussion on this issue. This extract from the contribution by their dance critic, Judith Mackrell, describes the dilemma perfectly:

> My own experience as a critic is to find myself on a constantly slid-ing scale of intimacy.
>
> The dance world is both small and loyal, with performers and choreographers routinely attending each other's shows ... I am ... on nodding terms with most of those I write about. It's hard for me to think of myself as an anonymous, detached observer of the scene...
>
> But just because it is complicated does not make it a bad thing. Dance is created live on bodies, it's a communal art form, and no critic can really understand what they are writing about if they sim-ply view it from the safe distance of the stage...
>
> ... I always hope to be surprised, converted and informed by any new work, regardless of my past knowledge of its creator. But if I see a bad piece by a choreographer I admire, or a bad perfor-mance by a talented dancer, I can't deny that I'm likely to be more interested in why the result was bad than I would be with someone whose work I hadn't rated highly in the past.
>
> We play a double game as critics. We do our best to erase per-sonal loyalties from our writing, yet we are hired for our personal opinions and our personal knowledge. We aspire to being objective, yet it's our involvement with the art form and the practitioners that makes us do the job.[13]

While you're trying to balance your relationship with your editor, you also have the opportunity to develop relationships with the people

about whose work you have to write. This can be a huge privilege and one of the best things about the role; it can be a chore or, the worst-case scenario, it can be a deadly mistake.

The privilege route is personally flattering and professionally pure gold. As you will have noticed, being a reviewer seldom stops with writing the reviews. At its most exalted, the role demands that you live at the cutting edge of artistic developments and bring to them the sophisticated understanding that you can only achieve if you live, breathe and sit around in bars with the artists. In the more popular fields, it often means writing interviews, features and even news as well. Critics in the quality press frequently move on to write important cultural essays or authoritative biographies of major artists. Many reviewers are considered to be valued specialists by their publications and when a big story breaks in their area, they can make an exceptional contribution to the coverage because they have the trust of the gatekeepers and the main players.

An important trade-off is often made here: for a critic, the most important and often the most fun aspect of the role involves visiting international festivals or exhibitions. These trips are a big item on an editorial budget. Why, asks the editor, should I send a critic to the Venice Biennale or the Cork Opera Festival if all the paper gets out of it is a genteel 300-word notice about work the readers will probably never experience, accompanied by a photograph of a blob of concrete or a grimacing, over-made-up 300lb tenor? I could spend the same money sending a reporter to Afghanistan, with page-one news guaranteed. If the reviewer can be trusted to treat those events as news-gathering opportunities, and can be relied upon to squeeze a news item out of every visit, that weight in the budget is justified.

A good network of contacts is essential if a reviewer is to add news value to a trip. If a film critic is at the Cannes Film Festival, for example, and the next project for a big Hollywood star is announced, the critic has the opportunity to negotiate an exclusive interview with the star and get his hotel bill offset against a jump in the readership

figures. A good relationship with either the star or the publicist will be invaluable at this point.

What happens if the story isn't such a win-win proposition? Suppose the star is papped strolling on the beach hand-in-hand with a mystery hunk? The publication, knowing that star and reviewer get along, will lean on the reviewer to get the story. The reviewer will risk the relationship if he or she does that, and may well turn off his or her phone and claim, later, to have been watching a documentary masterpiece about camel-herders in Tajikistan in an underground screening theatre where there was just no signal.

A wise reviewer who becomes a friend of an artist may often choose not to let their editor know. This not only saves them from conflicts of interest but also protects them against suspicion that they can't be objective. Some editors – the toxic tendency again – will see no benefit and considerable harm in such a connection. Others will weigh the benefits of the reviewer's special relationship against the likelihood that he or she is pulling punches in writing about a friend's work.

So should you pull punches when you're writing about a friend's work? Will you even know that you're doing that?

Jonathan Jones, the *Guardian*'s art critic, opened this debate by taking the view that all relationships corrupt the critic.

Can artists and critics ever be friends? It might be different for music or film critics but for an art critic in Britain in the 21st century it has become an urgent question: critics have become so close to artists, they practically do their laundry.

I'm not going to throw around nasty words such as corruption, or flattery, or courtier. Or before I start throwing around those words, I will try to give a sympathetic account of why so many critics today regard friendship as crucial to their job ... This genre of writing has gone into overdrive as the modern art world has become better at representing itself. In the face of lazy, hostile reviewers, contemporary art sought to speak for itself, and thought the critic's role might make this possible. David Sylvester's fame as a critic rests not on

his own remarks but on the interviews he recorded with Francis Bacon. Was Sylvester what you'd call a friend of Bacon? It seems to have been a more careful relationship than that...

For me, writing about art is an honest examination of response. Does it really work? Is it really powerful? These questions seem worth asking in a culture saturated with art. This is a great time to be an art critic, with so many bloated reputations to puncture. All that is stopping us is friendship.[14]

In response, Michael Billington, one of the most gifted and respected of Britain's theatre critics, argued that he and his colleagues were much more motivated to keep themselves pure.

... If a critic can't write honestly about friends or acquaintances, he or she should change jobs: I'd even suggest that the imperative of writing to a deadline forces one to shed old loyalties. It's not 'what do you do about friends?' that's the big issue. It's 'what do you do about enemies?'. That's putting it melodramatically. But any critic, in the course of a career, falls into unwanted feuds with living artists.

In recent years I have clearly angered Trevor Nunn, Jonathan Miller and Dominic Dromgoole and we have even been known to exchange letters. But, although I don't expect them to believe me, I approach any new production they do with a totally open mind: not because I'm a saint but because it's the only practical way to function.

This, in the end, is the point. Critics and artists may, if they choose, wine and dine together, sleep together and even, in extreme circumstances, marry each other (I did actually hear of a Russian soprano who wed a music critic). But, when it comes to the hazardous business of putting words on paper, something strange happens. Old friendships and enmities are temporarily banished and you would, if the need arose, give your own grandmother a stinking review if she committed the cardinal sin: that of perpetrating bad art.[15]

Music reviewers, especially rock writers, often make the point that the gap between stage and audience is impossible to cross, especially when it widens to a gulf when comparing their own workaday lifestyles with the fabulous existence of the artists, who may well commute by private jet between their several luxurious mansions. In most of the performing arts, the reviewer and the creator meet briefly and uneasily in over-decorated hotel rooms, chaperoned by twitchy publicists.

The star's schedule may allow for one such meeting every 20 minutes for three or four days; in a global promotion tour, they will give hundreds of interviews, in almost all of them answering the same questions, on a one-city-per-day schedule. At the end of this process, even the most robust, articulate and committed of performers is on the edge of catatonia. The scenes in the film *Notting Hill*, in which Hugh Grant poses as a reporter in order to talk to Julia Roberts, could be documentary rather than fiction – that's exactly how it is. The interview is more of a ritual of validation than a human exchange. It is certainly no basis for any kind of human connection, let alone a friendship.

Despite these conditions, relationships do develop. If you're a beginning reviewer, you should keep in mind that being nice to you is part of the artist's job, and some of them do it very well. So you may, in fact, find yourself invited to hang out on the yacht or discuss philosophy at the poolside with the aid of think-deeper drugs. The star may call you by your name, ask after your family and give you his or her phone number. The star may then forget your name, your face and your family and the phone will be answered by the assistant's assistant. Or maybe they'll call and invite you to a romantic dinner at one of those restaurants with a three-month waiting list. Either way, never forget that this is a professional relationship.

Back at the Glastonbury festival, Andrew Collins writes of the time he made that mistake.

'Good luck, Jarvis!' I shout over to the passing Pulp frontman, whom I know well enough to shout over to, adding, 'Don't ruin it for us!'

Not just, 'Don't ruin it' but 'Don't ruin it for *us*?'

Jarvis narrows his eyes, casts me a withering look and walks on by in his brown pin-striped suit... At the 11th hour, Pulp have been gifted the headline slot on the Pyramid Stage after the Stone Roses pulled out because of a broken arm. Another momentous generational and cultural handover. They keep happening. It's Britpop's big moment. The irony is I've ruined it. Assorted looks of disdain come from the rest of the social circle ... in the backstage paddock.
It's easy to go too far when familiarity replaces professional detachment. I call after Jarvis, shouting 'I was only joking!' but to deaf ears. It came out all wrong and my good luck wishes have turned to ash in my idiot mouth.

... I should know better. They're the important ones, not us. They make the music, they take the risks, they tour the world; we just write about them doing it. We don't make them, they make us.
Hard-and-fast rule: never make the mistake of thinking you are the band's friend.

... At what point in life does being drunk stop being a legitimate excuse?[16]

In the *Guardian* debate, the rock critic, Alex Petridis, advances the view that most of the artists in his arena are people you wouldn't want to know anyway:

If the history of rock music tells you anything, it's that the most interesting music is usually made by people so dreadful that, were they to come round and knock on your door, you'd turn the lights off and lie on the floor. Lou Reed, James Brown, Brian Wilson, John Lennon: you can and should marvel at their mercurial genius, but why on earth would you want to hang out with them when you could be in the pub with your proper friends, who – unless you need to pick your friends more wisely – aren't going to take vast quantities

of meth-amphetamine and behave like an unspeakable shit to everyone, or threaten to shoot you for using their private toilet, or sit around in their bathrobe for years on end doing coke or suddenly launch into a hilarious impersonation of a mentally handicapped person while lecturing you on world peace and forcing you to listen to their wife's avant-garde singing?

As the late rock critic Lester Bangs pointed out, 'I don't know how much time you have spent around big-time rock and roll bands. You may not think so, but the less the luckier you are in most cases.' I'm certainly not complaining about my job (no rock critic should complain about their job, lest someone interrupt with the not-unreasonable suggestion that you go and do something useful for a living instead). I'm simply noting that if you know your stuff, the idea of becoming pally with a rock musician should be anathema to you: you should know that the people you admire the most are unlikely to be people you'd want to pick as friends.

And really, what sort of idiot becomes a critic in order to make friends? The clue's in the job title. You're expected to criticise people, and people don't like being criticised. The role of a critic can be many things, but one thing it patently is not is a popularity contest. And to pre-empt the inevitable response, I'm perfectly aware that in my case that's just as well.[17]

In other arts, however, creative incest is almost unavoidable. Here the *Guardian*'s literary editor, Claire Armistead, explains how things work in the world of books:

I was horrified when I moved (from theatre) to literary editing to find that ... independence had so little place on the books pages. ... It took me a while to understand how complex and far-reaching the reasons for this are, and how embedded it is in our history, our culture and even our economic set-up. The primary and unavoidable problem is that writers are always reviewed by writers ... It takes far longer to read a book than to watch even the longest Shakespeare play, which makes it pretty much impossible to earn

a living through book reviewing alone. So most reviewers have 'day jobs' – usually their own writing, or some sort of teaching, both of which bring with them dependencies and compromises. A reviewer might not know a writer personally, but share an agent or publisher with them. An academic might be asked to review a book by a rival in the same discipline...

My antennae still twitch when a writer volunteers a review – I'm still always looking out for the motive. But now when someone mouths off to me about the corruption of book critics, I just smile sweetly and ask for specific examples. Often it comes down to a difference of opinion, which brings us to the one thing all art forms have in common: everybody loves to hate critics.[18]

Interestingly, it is almost a cliché of editing books pages that the newly appointed supremo will vow to put an end to the vile network of ass-kissing and back-scratching that has the world of literature ensnared in its deadly web. They embark on a heroic quest for non-aligned, friendless and incorruptible writers to contribute reviews as pure as 40% proof Polish vodka, and, just as vodka that claims to be Polish and 40% proof is seldom what it says on the label, they find that a critic without connections is seldom as pure as all that either. And every week the yawning empty spaces in the page-making programme flicker at them as if mocking their naivety. So the heroic quest is quietly forgotten and their pages are once more filled by laudatory notices from the writer's editor's husband's research student or the writer's wife's client.

THE GATEKEEPERS

If everybody loves to hate critics, nobody has the right to hate them more than the gatekeepers, the people who pitch their stories, fix their press passes and, far more often than any critic will admit, write their copy. Oh yes, they do. Just try checking the words of a book's press release against its 'reviews' in the provincial press.

Most of these people are publicists. It is a honourable profession, although a lot of its practitioners have a highly individual sense of honour. Did you read or have you seen Christopher Buckley's *Thank You For Smoking*? There really are public relations officers for the tobacco industry, for the arms industry, for brutally repressive governments and for even less attractive institutions and people. When you're dealing with an arts publicist, remember that they could have entered much more questionable branches of the profession. Even if you've just caught them out in a great fat lie and they've given your prized exclusive interview to your biggest rival.

When you have an influential role on a major publication, publicists will call, email and text you day and night and they will be warm, friendly, clever, thoughtful, charming and probably flirtatious. The minute I was on Facebook I was blitzed by messages from publicists wanting to be my friend. When you are a wannabe trying to break into the business, however, publicists will ignore you, block your emails and delete your number. Then it will be up to you to bring every ounce of interpersonal skill to the task of getting their attention. It's a good idea to have a goldfish memory when it comes to the behaviour induced by the inherent cruelty of media life.

As with journalists, straight-dealing professionalism is the foundation of a good career for a publicist and many of the gatekeepers with whom a reviewer does business will choose this path. Feel free to develop a close working relationship with anyone who speaks the truth and delivers what they promise. Remember, of course, that a working relationship is realistically all you can develop in this situation. Okay, a few people every decade fall in love and get married, but it's rare. Generally, a publicist may act like your best friend but when the manure hits the air-conditioning they will remember that their clients pay their salary, not you. Like artists, some publicists are professionally very friendly. One who I talked to a lot even asked me and my partner to her big swanky wedding. A few months later, when I moved jobs and was no longer any use to her, she never called me or returned my calls again.

There are toxic publicists. Especially in pop music. Thinking about it, every single one of the publicists I've worked with whose client was an all-time-great rock star has been a total shit. May it be different for you. May you talk to a PR for a golden god of rock'n'roll who is a genuine, 22–carat, absolute pussycat. I've never met one, but the law of probability suggests that they must exist. Like antimatter particles.

The major fault of a toxic gatekeeper is not the arrogance, the abuse or the flat-out uselessness. It's the lying. Between a journalist and a public relations executive, very little is ever committed to print. Sometimes you may be asked to submit questions before an interview. Sometimes you or your publication may have to sign embargo or confidentiality agreements. Mostly, the deals are done on a promise, without even a handshake as you may well be in different cities at the time. So when a publicist promises you that you will be admitted backstage, given seats in the Golden Circle or granted the very first interview in your field, there is no guarantee that these things will happen. Given the stomach-searing anxiety of never knowing that your exclusive really is exclusive until you see the morning's papers, I should have a lot more grey hair than I've got.

In fairness, if a publicist lies it may not be their fault. The client may have lied to them. The client may have changed his or her mind. Divas can be real divas. A distinguished film director once told me that his new movie would be made with some hugely expensive but counsel-of-perfection technical process. He told his publicist the same thing. Knowing how costly the process was, I decided to check with the producers and found out that the man had lied. Fortunately, I found out before I wrote anything. In a situation like that, reviewer and gatekeeper are companions in misfortune.

Also in fairness, journalists can deceive publicists, and that too can be unwitting. In the interests of building a good relationship with a gatekeeper, you should never, ever promise what you can't deliver; you say, 'It's on tomorrow's centre spread at the moment and the page won't change unless a major news story breaks'. You don't say, 'It's on tomor-

row's centre spread and nothing can change that'. One of my very best, jammiest, most ground-breaking exclusives lost the centre spread because some major communist dictator upped and died and the whole page was remade. I was gutted, but so was the star's publicist.

Gatekeepers have considerable power. If they don't want you at an event that they're promoting, they can and will deny you privileged access. Contact with top Hollywood talent is almost entirely controlled by three or four leading public relations firms. They can and do blacklist journalists who write negative copy. So an unhappy hack who has offended one star may find that the whole of the rest of the client list and all their works are officially off-limits to them until either they or the publicist in question moves to another job. That's before the stars, and the stars' people, get involved. It is said that Tom Hanks rejected fourteen writers proposed by *Rolling Stone* magazine before they suggested one he considered acceptable.

At this level, public relations is very much about relationships. The Hollywood gatekeepers protect their clients fiercely and work through a network of 'tastemakers', meaning journalists who are both influential and trusted. Tastemakers often know each other and value each other's judgement, so a favourable opinion from one will be passed on to the rest and become an elite consensus before a word has appeared in print. With a city-based press in the US, rather than national media, this has become an established route for bypassing the crude, old-fashioned process of screening a movie and seeing if the reviewers like it.

Gatekeepers and reviewers have a symbiotic relationship; they accuse each other of being arrogant, idle and obnoxious. They can't trust each other but they have to gamble on the other's integrity in every transaction. They are capable of spats, vendettas and comfortable long-term relationships. Neither can function without the other. When the relationship is good, it's highly productive. When it's not, it's nasty. A gatekeeper can't quite ruin a reviewer's career, but he or she can certainly try.

6. THE BAD STUFF

Writing a good review is a joy. Writing a bad review is a challenge. Of all the difficult balances to find as a critic, the one between honest dislike, informed disapproval and malicious damage is probably the hardest.

Inside the media, a reviewer will sometimes be attacked for being too generous to a work. Bad reviews are good business, as the extraordinary and ever-growing number of websites like www.rottentomatoes.com suggest. Dorothy Parker was once accused of reviewing Ernest Hemingway's short stories too kindly and wrote an apology so steeped in irony that her accuser probably withered to dust on reading it. In general, however, the person most likely to accuse you of excessive positivism is your editor, who may take your enthusiasm to indicate a lack of integrity.

Your editor is unlikely to take issue with a negative review. In some branches of the media, writers – often women, for reasons that can't be pro-feminist – are paid large salaries for writing like Rottweilers. The satirical magazine *Private Eye* caricatures them in their columnist Glenda Slagg. I know several decent feature writers who took the Glenda shilling, bought sports cars, sent their children to expensive schools and buried their consciences at the back of the drawer in which they kept lawyers' letters.

Civilians, with no knowledge of or interest in the work in question, usually enjoy reading a bad review. If the critic is simply expressing

their own loathing and disgust, they enjoy sharing the vile experience all the more. Bad reviews are readership builders. They give the critic at least an illusion of great authority and deep wisdom. Only if advertisers pull out or if you and your publication are sued for libel will your judgement be called into question by your editor for being too harsh. From the management's viewpoint, bad reviews indicate robust independence of thought.

In the creative arena, however, bad reviews will earn you the eternal enmity of many of your subjects and also of many of their gatekeepers. Here is A A Gill, notoriously bitchy television reviewer for the *Sunday Times*, describing his first and only visit to the Edinburgh International Television Festival where the great and good of the industry gather annually to argue and debate.

> Damn, damn, damn, damn. I've missed the Edinburgh International TV Festival again. That's a whole decade in which I've been unable to make it to the riveting clan gathering of MacTristram. Every year, someone perky and lively called something like Perky Ann Lively phones and asks if I'll be coming to Edinburgh to take part in a panel discussion entitled Critics: Whining Egocentric Parasitic Tasteless Morons or Wannabe Reality-Show Contestants? I did go once. I was a new boy, and keen. I thought it only fair I should show up for free and frank discussions with the thin-skinned, infantile, bitter vanity boxes who make television. You have no idea what concentrated venom feels like until you've walked through the bar of the George Hotel in Edinburgh at 11pm with 500 assorted TV purveyors giving you the evils.[19]

Gill is a great bravura writer who rarely contributes anything other than opinion pieces or reviews to his newspaper. Negotiating interviews, sourcing insider information for state-of-the-industry features, checking out hot rumours with those in a position to know the truth – he doesn't do that. He doesn't even need access to press launches or screenings. If he was banned or blacklisted, it would make no differ-

ence to his ability to function. All he has to do to acquire a factual basis for his journalism is turn on his TV or show up at a restaurant and eat a meal after making a reservation in the name of Smith. He is therefore free to be as exuberantly and entertainingly abusive as he likes.

You may not be in this position. Even if you are in this position, you may not want the experience of getting the evils from the 500 most influential people in the art that you love. All the same, you may be outraged, offended or deeply depressed by a piece of work that you consider to be bad. You may consider it your duty to condemn it; even beyond that, you may consider that the issues raised are so important that you and your publication will serve society best by starting a global debate on them. So what's the worst that can happen in this situation?

DEFAMATION – LIBEL AND SLANDER

Apart from the respect which every journalist should have for the truth, you should also understand the financial implications of what US law describes as a reckless approach to reality. Media newbies can get drunk with power when they see how easy it is to give any chimera the appearance of the truth just by awarding it the endorsement of publication. It's possible to forget that there is such a thing as reality when you can make things seem real so easily. So when reality bites back, it's a shock.

Whenever you write something for others to read, you must ensure that it is true or risk a legal action for defamation. Even an email sent on your office intranet can be 'actionable' – meaning that anyone it defames can bring a legal action against the author.

Hundreds of such actions are begun every year, and in Britain, where the laws of defamation are remarkably easy to use and weighted in favour of the plaintiff, or alleged victim, they are usually settled out of court for uncomfortably substantial sums. Most mainstream

publications retain their own lawyers who review every potentially sensitive piece early in the publishing process. A review filed late at night before a newspaper 'goes to bed' can hold up the whole edition, at a cost of tens of thousands, if it has to be rewritten for legal reasons. If the system fails, and something actionable appears in print, the cost to the publication of the inevitable settlement will be even higher. In rare cases a vindictive victim will insist on a day in court, sending the cost into the stratosphere. A reviewer who costs a publication money in this way will have lowered their professional reputation and is very likely to get fired.

If you are studying journalism, you will explore the laws of defamation more thoroughly than I do in this book. What follows, therefore, is a short guide to libel for writers who will not cover this ground in the course of their studies.

Every country in the world, and every state in America, has its own laws of defamation, so wherever you may be reading this you should consider, in addition to what follows, your own local legislation. Internet publication, however, means that material published on the Web is subject to the laws of every country in which it can be read. As the procession of celebrities who have instructed lawyers in London has demonstrated in recent years, this means that the British laws of defamation can be used by anyone anywhere in the world.

The law of defamation covers any statement that damages the reputation of a person or an organisation. Oral defamation, in which something damaging is said, is known as slander and, because it is difficult to prove, is less often a subject of legal action than published defamation, known as libel. A damaging statement carried in any form of publication can be actionable – letter, email, newspaper, magazine, leaflet, TV or radio broadcast, any on-line publication. The essence of the offence is that the untruthful statement has been shared with other people. Fiction, such as a play, novel or serial, can also be libellous if a character appears to be so like a real-life person that it can be considered a comment on that person.

Defamation is part of the civil law, meaning that the offence is not considered a crime but the injured party can sue for damages – a financial award made by a court in compensation for the injury. Most of the cases that come to court are tried by a jury, which greatly increases the expense of the procedure. In the US, the law of libel has developed in the shadow of the constitutional commitment to free speech. A successful legal action needs to show that the libel was published recklessly – meaning without any effort to check the facts – and that the victim has suffered measurable damage, usually in terms of lost earnings. In the UK the law is more generous; it is designed to protect against untruthful, malicious or frivolous damage. A libel victim can sue on the grounds that they have been exposed to hatred, ridicule or contempt, that they have been shunned or avoided, that the libel discredits them in their trade, business or profession or that they have been generally lowered in the eyes of right-thinking members of society. These wonderfully universal criteria also add advantage to the plaintiff's side in a libel action.

One of the most famous libel cases lost by a critic involved the actress Charlotte Cornwell, who sued the TV critic of *The Sunday People* newspaper, a writer in the Glenda Slagg mould who was happy to live up to her by-line: 'the Bitch on the Box'. Her style was randomly abusive and she awarded Cornwell the title of 'Wally of the Week' with a citation that impugned everything from the actress's voice to her vital statistics. Because it comprehensively trashed everything that an actor would consider vital to a good career, the article was almost a text-book definition of defamation. The court case was a bonanza for the tabloids, which reported the action with many a malicious headline commenting on the actress's figure. At the first hearing, however, she won substantial damages.

The newspaper, with deeper pockets than its victim, appealed against the first judgement and the action dragged on over two more years. Although Cornwell was finally victorious once more, the damages she won did not cover the costs of the action, which were award-

ed against her. The possibility of this outcome is the main argument which a responsible lawyer will put forward to dissuade an injured client who wants to sue for libel.

If you want to express highly critical opinions of a performer or a work without falling foul of the law of libel, you need to maintain these standards:

1. Get your facts right and make sure you can prove them – in legal terms. Lawyers are seldom impressed by potential witness statements; this means that if you say you can produce someone to confirm the point at issue, they won't regard that as proof. Lawyers like everything in writing, signed and dated. Check any sensitive information with an authoritative source as a matter of routine, but with actionable material you should have, or be able to obtain easily, written confirmation from a good authority. If you can't get that, don't write anything damaging that you can't prove, no matter how much you believe that it is true.

Suppose, for instance, you want to explain that the schlocky film you hated was only made because the producer was trying to hide some profits from the tax authorities. 'Everyone' in the industry may know that this was the case. The producer himself may have told you so. But if you haven't got an email confirming it, and preferably the producer's accounts, you won't be able to prove it in legal terms.

A particularly dangerous aspect of British libel law is that the burden of proof lies with the defendant. That means that, in the event of legal action, you would have to prove that what you had written was true; your accused does NOT have to prove that what you wrote was untrue. Rumour, gossip and widely held beliefs mean nothing if you can't prove the facts. Even if you take care to present the suspect information as nothing but tittle-tattle, you are still guilty of having 'broadcast' the libel. The two most effective defences against a libel claim, justification and fair comment, both require the best possible factual basis for the disputed statement.

2. Beyond facts, be careful with implications. Remember that the law includes the principle of a reasonable interpretation of what you write. Your intention need not be malicious. What you intended to write is not important – what counts is how your reader might understand it. That means that you can be liable for an innocent mistake, so be very careful in checking your own copy. Don't use innuendo or vague hints of wrongdoing, because they can be as actionable as an outright allegation. Repeating a libellous rumour, even if you make it clear that this is what you're doing, is also actionable.

3. Make good notes and keep them. In some cases, a reporter's notes, if they are legible and dated, can be considered as evidence. I was once threatened with legal action by a TV presenter who claimed I had never interviewed her and fabricated all the quotes in my article. Worse, she claimed she'd never met me but that I was sleeping with her housemate and had fabricated the interview based on pillow talk.

Media attention induces crazy behaviour. I had interviewed the woman, formally, explaining the content of the article carefully first, so she was well aware that she was lying about me. She had done that because she had come under pressure from a colleague. My feature quoted her accurately but the fact that she'd appeared in a magazine article had made her boss jealous of the attention. So her boss had denounced her to their department head and was trying to get her fired.

To her discredit, my editor immediately believed her – people do have an irrational tendency to think that faces they see on the TV speak only gospel truth. Fortunately, I had pages of immaculate short-hand notes of the interview to disprove the allegation; once they were copied and faxed to the lawyers, the presenter fell silent. But no, she never apologised. As for my doubting editor, she complained that I was disloyal when I moved to a better job as soon as I could.

4. Don't exaggerate. This can be a hard rule to keep if you are writing for a tabloid or a shrieking gossip site, but it will save you from suffering the same fate as the Bitch on the Box. You will want to ramp up your language to write bold, arresting copy, but be careful of the literal and the implied meaning of those lurid adjectives. If you want to say that a performer is too thin, it's fine to call her a stick insect but not to say that she's anorexic; even a term that implies an eating disorder, such as 'thinspirational', needs to be used with care. Be particularly careful in talking about a performer who looks drunk or drugged-up. Ever noticed how fond rock writers are of vague expressions like 'shambolic'?

5. Don't put your trust in a balanced argument. If you've made a libellous statement, the fact that you follow it with an opposing opinion does not make that OK. The principle of balance is often an internal rule in media organisations but it is not a defence against defamation.

HOW TO BE BAD

If you want to write a bad review, you'll need to draw on your reserves of two qualities: wit and wisdom. Wit may earn you a place in the pantheon of all-time-great critics. If Dorothy Parker's admiration for Ernest Hemingway is never quoted, her harsher judgements, especially 'This is not a novel to be tossed aside lightly. It should be thrown with great force' are among the most famous epithets of our times. Her writing is often described as 'vicious', which is what you get for being a woman in a man's world. Her judgement is incisive but her touch was always very light, even when she deliberately chose to review a book that she could rubbish. She put up her hand for the historical romance entitled *The Cardinal's Mistress*, a novel written by the young Benito Mussolini some years before he became the fascist dictator of Italy. Parker was an active left-winger and, although an atheist herself, came from a

partly Jewish family. If this review seems, with the benefit of hindsight, somewhat too polite, consider that it appeared in 1928, more than a decade before Mussolini also became Adolf Hitler's closest ally.

> I had all sorts of happy plans about (this book) ... I was going to kid the tripe out of it. At last, I thought, had come my big chance to show up this guy Mussolini. A regular Roman holiday, that's what it was going to be.
>
> Well, the joke was on me. There will be little kidding out of me on the subject of the Mussolini masterpiece for I am absolutely unable to read my way through it. I tried – the Lord knows I tried. I worked, to employ the most inept simile in the language, like a dog. I put on my oldest clothes ... denied myself to my bill-collectors, backed the bureau against the door and set myself to my task. And I got exactly nowhere with that book. From the time I cracked its covers to that whirling moment, much later, when I threw myself exhausted on my bed, it had me licked...
>
> In fairness to the author – and I would strip a gear any time in an effort to be square toward that boy – it is in my line of duty to admit that ... when I am given a costume romance beginning, 'From the tiny churches hidden within the newly budding verdure of the valleys, the evensong of the Ave Maria floated gently forth and died upon the lake,' my only wish is that I, too, might float gently forth and die, and I'm not particular whether it's upon the lake or on dry land.[20]

Scrupulously, Parker takes issue only with the literary quality of *The Cardinal's Mistress*, not with the author's politics, although her readership would have been well aware of them. When a performance is the object of a critic's condemnation, the issue of quality is more complex. Here is *The Spectator*'s drama reviewer, Toby Young, explaining exactly how and why a play was terrible.

> I emerged from the press night of *Heroes* last week to find Will Self (novelist and columnist) uncharacteristically lost for words. 'Why...

what... I mean... I don't understand,' he said, shaking his head in bafflement. A few yards up the street, three of my fellow theatre critics were congregated by the exit, all staring at each other in shell-shocked disbelief. 'Oh my God,' said one of them, grabbing me by the lapels as I walked past. 'What the fuck was that?' *Heroes* is one of those plays that is so breathtakingly feeble it leaves you amazed that it ever got produced. What on earth are John Hurt, Richard Griffiths and Ken Stott doing in this drek? And how in God's name did the producers manage to persuade Tom Stoppard, of all people, to translate it from the French? I hope they paid him at least a million pounds because the alternative explanation – that his judgment has completely deserted him – is too awful to contemplate.

Clearly, the producers of Heroes are hoping to replicate the success of *Art*, another French three-hander that was also translated by a distinguished British playwright. Their excuse, then, is that they're just trying to make a bit of money. But, really, are there no limits to their cynicism? Why not hire Paris Hilton and get her to strip down to her underwear and stand in a cage for six weeks? I'd be happier to watch that than endure another performance of *Heroes*.[21]

Ebulliently damning as this notice is, it evaluates the reasons why Young hated the play in detail. Notice that he manages to be hilariously rude about the production but exonerates the actors and the translator – all distinguished in their fields – from any blame. It's usually unfair to blame a translator for a bad work, since their role only concerns the language and doesn't extend to any major creative contribution. Blame for a bad translation, however, belongs nowhere else.

Blaming actors is something I chose never to do. I had not been reviewing for long before I realised that a bad actor can still give a good performance if used cleverly by a good director. Conversely, good actors can be hideously miscast and one can hardly blame a member of the most insecure profession there is for taking a job that wasn't

ideally suited to their talents. More and more, Hollywood stars have followed Kevin Spacey and Nicole Kidman onto the London stage and some of them are more accomplished screen actors than theatre performers. Nevertheless, they have brought new audiences to an art that is struggling against global, commercial pressure.

In screen performances, the filming is a process of fragmentation and many actors aren't in a position to judge the way their images are used – for good or ill. One of the actors in one of the finest TV dramas ever made, *The Jewel In The Crown*, told me that, as the cast and crew travelled all over India from location to location, filming thirteen one-hour episodes, they lost all sense of judgement about the work as a whole and came home not knowing whether they had made a masterpiece or 'the greatest curried turkey of all time'. I considered the question and decided that there was no justification for blaming an actor for anything; it would be unfair to someone with very little control over the final use of their work. I'm just so glad that I'm in the nice cosy role of the writer and I don't have to go to auditions.

However, one of the most gifted and popular reviewers currently writing takes a more robust approach. Here is Mark Kermode's notice for *Pirates of the Caribbean: Dead Man's Chest*, famous for calling Orlando Bloom 'Mr Bland'.

Given my contempt for the first *Pirates of the Caribbean* movie, a triumph of turgid theme-park hackery over the art of cinema, it was assumed that I would have nothing positive to say about this sequel. On the contrary: the digitally enhanced squid-face of villain Davy Jones... is very well rendered... Bill Nighy performs the human duties behind the high-tech make-up, lending an air of rancid fun to this slimy sea beast, who yo-ho-hos around the ocean accompanied by a crew of rum-sodden *crustaceans*...

The fact that Johnny Depp received an Oscar nomination for his boggle-eyed, drawl-mouthed Keith Richards' impression doesn't change my opinion that the role of Jack Sparrow has produced some of the actor's very worst work to date...

As for poor old Orlando Bloom, where does one start to document the tidal wave of wetness which he brings to these proceedings? No matter how much sea water Verbinski throws at the set, nothing gets as damp as Mr Bland, whose expressions run the gamut from perky to peeved with occasional interludes of petulance. (Keira) Knightley... puts her best teeth forward and does her haughty Head Girl act... Lumpen direction, lousy writing and pouting performances aside, the worst thing about *Dead Man's Chest* is its interminable length. The entire *Pirates of the Caribbean* franchise may be a horrible indicator of the decline of narrative cinema (and probably Western civilisation), but the rank consumerist decrepitude of it all would be tolerable if the film wasn't quite so boring.[22]

The objection here, set forth in redolent language – I love the 'rum-sodden crustaceans – and with ample evidence for the argument, is simply that the movie is bad, boring and long. It is possible to have subtler but equally powerful feelings and express them just as forcefully. Here is Dirk Bogarde being wonderfully entertaining about a biography of the painter Dora Carrington, one of the group of artists and intellectuals who gathered in London in the early twentieth century and were known as the Bloomsbury Group. Bogarde found the book dull and the subject irritating, but his review is one of the most entertaining ever written. It is characteristically and floridly personal. Bogarde was a British actor who progressed from 1950s matinee idol to 1970s art-house icon in Joseph Losey's *The Servant* and Luchino Visconti's *Death In Venice*. Always disdainful of mediocrity, he withdrew from acting rather than accept uninteresting parts and began to write, beginning with a masterly three-part autobiography which gave his admirers as much pleasure as his screen performances.

After 20 years in Provence, he moved back to London in the late 1980s, shortly before his partner died from cancer. These dark days lightened when 'a pleasant young man,' Nicholas Shakespeare, now a renowned author but then the literary editor of the *Daily Telegraph*,

asked him if he would care to review some books. So Bogarde began a third career that proved as dazzling as the first two.

> Well, all right then. If you really do want to know any more about the tiresome Bloomsberries, Gretchen Gerzina's splendidly researched, dry-as-old-bones, fully detailed, unwitty, light-as-a-school-dumpling but scholarly, even loving in a way, book is for you.
>
> ... Strangely Gerzina places (Dora Carrington) on the fringe of the Bloomsbury set which is a bit dotty when you realise that the players were leaping all around her and that she was caught in the eye of the storm...
>
> She loathed her femininity, hated the 'lumps of flesh' which hang before me and detested ... any form of sexuality. But goodness, she could paint. Painting provided almost the whole structure for her life and Gerzina makes this clear without passing a great deal of comment beyond some predictable Freudian suggestions.
>
> So this shy, faux-cock-teaser, this shrew, this timid child, pranced and leaped around her Bloomsbury maypole ... danced and capered with all her ribbons when the centre ... was in truth the complete love of her life, amazingly, until the day that she died: Lytton Strachey
>
> ... No one else really mattered to her. Although she flirted and was bedded, she rebuffed, and recalled, with tiresome regularity, a long series of lovers both male and female. She chucked her Augustus-John-image gipsy skirts and off-the-shoulder blouses for breeches and hacking jackets, and cantered over the downs when she wasn't painting, falling in love or driving someone mad or writing her wonderfully misspelled letters.[23]

A reviewer may want to go much further, and attack the morality of a work. You need an authoritative voice to do this but it does not have to be a pompous exercise. Journalistic writing is rarely subtle but it can still address complex issues. All that is necessary is clarity of thought, which can be difficult to achieve when you're deeply shocked and offended. Here is a famous notice by Roger Ebert, Pulitzer Prize-winning

critic with the *Chicago Sun-Times*, which explains why he hated David Lynch's film *Blue Velvet*, in which Isabella Rossellini and Dennis Hopper portray an obsessive, sado-masochistic relationship. It's not elegantly written and my guess is that Ebert had only a short time in which to compose it. All the same, he makes his reasoning crystal-clear.

> *Blue Velvet* contains scenes of such raw emotional energy that it's easy to understand why some critics have hailed it as a master-piece. A film this painful and wounding has to be given special consideration. And yet those very scenes of sexual despair are the tip-off to what's wrong with the movie. They're so strong that they deserve to be in a movie that is sincere, honest and true. But *Blue Velvet* surrounds them with a story that's marred by sophomoric satire and cheap shots. The director is either denying the strength of his material or trying to defuse it by pretending it's all part of a campy in-joke...
>
> Rossellini is asked to do things in this film that require real nerve ... She is asked to portray emotions that I imagine most actresses would rather not touch. She is degraded, slapped around, humili-ated and undressed in front of the camera. And when you ask an actress to endure those experiences, you should keep your side of the bargain by putting her in an important film.
>
> That's what Bernardo Bertolucci delivered when he put Marlon Brando and Maria Schneider through the ordeal of *Last Tango in Paris*. In *Blue Velvet*, Rossellini goes the whole distance but Lynch distances himself from her ordeal with his clever asides and witty little in-jokes. In a way, his behavior is more sadistic than the Hop-per character.
>
> What's worse? Slapping somebody around or standing back and finding the whole thing funny?[24]

You may also wish to start an argument with fellow critics who dis-agree with you. Here is Toby Young again, attacking both the play and those of his colleagues who have praised it:

Blackbird is the kind of play critics absolutely adore. Indeed, the reason it has managed to secure a birth in the West End – a rarity for a new straight play – is because it got such rave reviews at Edinburgh last year. For one thing, it's about paedophilia, and that enables the critics to congratulate the writer, David Harrower, on his 'bold' choice of subject-matter. They like playwrights who don't pander to commercial interests – it demonstrates how serious they are about their craft. In addition, Harrower's attitude to paedophilia is complex and nuanced – he refuses to condemn the middle-aged perpetrator, even though his victim was only 12 when he had sex with her. That's guaranteed to produce a chorus of approval from the critics – Harrower is even more 'courageous' than they first took him for, if that's possible. Best of all, it provides them with an excuse to distance themselves from the 'tabloid hysteria' that normally surrounds the treatment of this 'difficult' subject.

Of course, the fact that *Blackbird* has been showered with critical plaudits for such superficial reasons – the fact that it prompts such feelings of ineffable superiority in the breasts of metropolitan sophisticates – doesn't mean it's a bad play. The critics quite often end up praising plays that deserve to be praised for the wrong reasons. But, in point of fact, *Blackbird* is a bad play and the only reason it's been given such an easy ride is because Harrower's 'bravery' has bamboozled the critics and obscured its shortcomings.[25]

7. OPINION FATIGUE

Congratulations, you have a job. You are a regular reviewer for a well-read publication and you feel your dreams coming true all around you. For a few weeks, anyway. Then you sense a surfeit of pleasure. You feel your writing sagging under the strain of being brilliant every week. You collect your invitations and instead of euphoria you have a depressing *déjà vu* sensation. Another opening, another show. The honeymoon is over.

Jonathan Romney of the *Independent on Sunday* points to the dross phenomenon, the inescapable result of the fact that a reviewer sees far more mediocre or even bad work than good. 'The danger for today's film critic is that, with 12 to 14 new releases a week, the bad films can eat away your brain before you see the good ones.' His personal solution was to negotiate with his editor to review only one film each week.

Writing notices does feel predictable after a while, no matter how much you are plied with champagne, freebies and trips to exotic foreign festivals. In fact, it's when you start appreciating those things a little too much that you realise you're in danger of losing your touch. If you are starting to feel jaded, what about your readers? How can you be fascinating, week after week? How can you stop them defecting to your rivals in their tens of thousands? How can you keep it real? How can you stop yourself using revolting clichés like 'keep it real'?

Every columnist faces the challenge of fulfilling the expectations of their fans while still sparkling for those readers who aren't quite convinced of their genius yet. And of keeping themself amused at the same time, which is the key to the whole thing. So, sooner or later, you will have to vary the tone, pace or style of your writing to create the contrasts and the dynamism which keep it alive in the long haul. For some reviewers, it's a very long haul. Roger Ebert, at the time of writing, has been reviewing for the *Chicago Sun-Times* for 40 years. The late Sheridan Morley also put in 40 years as a critic, working for the BBC, *The Times*, *The Spectator* and *Punch*, among many others. Derek Malcolm, who officially retired as film critic for the *Guardian* in 2000 but was then lured to the *Evening Standard*, has over 30 years of regular reviews behind him.

If you're starting to bore yourself, be grateful. As long as your threshold of boredom is lower than that of your readers, you're fine. You can trust your own instincts as a writer to move up a level before you need to. Following are some strategies you could follow to break out of your own mould and refresh your style.

TEST YOUR READERS

If you're doing your job properly, your regular readers will be gaining a little knowledge every week. The third time you review a new Almodóvar movie, you won't need to explain who he is, what he's done and where Penelope Cruz fits in the picture. You can trust the guys to get it. You can surf a bit, enjoy yourself.

I decided to set my readers a little challenge when I came to review the final episode of *I, Claudius*, a drama series that was the precursor to *Rome* but based on the novels of Robert Graves and held in high critical esteem, although it was the sex, stabbing and seriously fit centurions that had kept half the country glued to Cicero's speeches and Caligula's dancing girls for three whole months. I had run out of superlatives round about episode seven, and Roman history between

Augustus and Claudius is as confusing as a French farce anyway. There was no dénouement to reveal, since the story had been in the public domain for almost 2,000 years.

I had bored myself with praising this marvel week after week but I wanted to celebrate the end of it somehow. Since my review appeared after the final episode aired, I reasoned that the loyal viewers would lose nothing if I wrote part of the notice in Latin. If you choose your words carefully, that dead language can be just about comprehensible. I personally had flunked Latin in school twice, but a new reporter had just joined the newspaper with a degree in Classical Studies, and she was up for translating for me, so the scheme seemed to have the blessing of the gods.

It did not have the blessing of my editor, one of the toxic tendency, who was outraged and told me I was crazy. I appealed over his head and was allowed to ask our newbie for a translation and take about two square inches of page space to try the readers' enthusiasm. Half-a-dozen delighted fans immediately sent approving messages in Latin to the Letters Editor. More followed and showing off scholarship became a game that kept Claudius's fans happy all week.

I admit that this was an extreme action and not one to be generally recommended. But if you start to feel a little *ennui* creeping in, you could ask yourself if your readers might appreciate a compliment to their intelligence now and then.

CHANGE YOUR STYLE

Given the sheer fun of writing a pastiche, it is surprising that reviewers don't do it more often. A style exercise, in which you review a piece in the style in which it was written, refreshes both writer and readers. Here is the legendary British theatre critic Kenneth Tynan welcoming the musical *Guys and Dolls* in the New York dialect made famous by the author Damon Runyon, upon whose short story the show was based.

Guys and Dolls, at which I am(sic) privileged to take a peek last evening, is a hundred-per-cent American musical caper, cooked up out of a story called 'The Idyll of Miss Sarah Brown,' by the late Damon Runyon, who is such a scribe as delights to give the English language a nice kick in the pants.

This particular fable takes place in and around Times Square in New York City, where many citizens do nothing but roll dice all night long, which is held by one and all, and specially the gendarmes, to be a great vice. Among the parties hopping around in the neighbourhood is a guy by the name of Nathan Detroit, who operates a floating dice game, and Miss Adelaide, his ever-loving pretty, who is sored up at this Nathan because after fourteen years engagement they are still nothing but engaged. Anyway, being short of ready scratch, Nathan lays a bet with a large gambler called Sky Masterson, the subject of the wager being whether The Sky can talk a certain Salvation Army doll into joining him on a trip to Havana. Naturally, Nathan figures that a nice doll such as this will die sooner, but by and by she and The Sky get to looking back and forth at each other, and before you know it is his sweet-pea ... Personally, I found myself laughing ha-ha last night more often than a guy in the critical dodge has any right to. And I am ready to up and drop on my knees before Frank Lesser, who writes the music and lyrics. In fact, this Lesser is maybe the best light composer in the world. In fact, the chances are that *Guys and Dolls* is not only a young masterpiece but the Beggar's Opera of Broadway.[26]

It's not the best *homage* to Damon Runyon ever written, but Tynan was only 26 years old at the time. Come the Sunday, Tynan's most distinguished opponent, the venerable Harold Hobson of the *Sunday Times*, condemned the show as immoral, derivative, blasphemous, stupid and boring, demanding, 'Is America really peopled with brutalised half-wits as this pasteurisation of Damon Runyon's stories implies?'

Tynan's editor was not impressed and ran a survey to find out if the readership preferred Tynan to his more pedestrian predecessor.

Tynan resigned. A few months later, he was hired by *The Observer*, the left-wing Sunday that is *The Sunday Times*' biggest competitor. There, given his head by a visionary editor, David Astor, who saw clearly how to position his paper as the voice of the iconoclastic new generation, Tynan soon became a central figure in British artistic life.

CHAMPION A CAUSE

This really means expecting more of yourself. Just what are you doing, enjoying your paid-for privileged access to great work, and everything that goes with that, and never thinking of paying back? Yes, you can be a passive consumer but that's not exactly interesting, is it? If you stay in your comfort zone and rest on your writing ability you will never grow in stature and your career is likely to drift into a death spiral. To be a contender you should do more.

Once you are out of the area in which you can't quite believe you're actually a real reviewer, it's time to look around for somewhere to take your stand. A reviewer's role should go beyond dashing off amusing critiques garnished with a little specialist information. Before you is a whole artistic world that is growing, developing, facing challenges and suffering setbacks. Start asking yourself how you feel about that.

Many reviewers are naturally drawn to the work of a particular artist; they find themselves on a mission to explain exactly why that work is so significant and in doing that form a friendship with the creator. The logical progression of that relationship is then to become their biographer, authority, curator or even executor. David Sylvester was generally considered to be one of Britain's most influential critics of contemporary art. He took up the work of Francis Bacon as a young reviewer and became that painter's champion for the rest of his life.

Sylvester made and maintained lasting friendships with many artists, including Bacon, Giacometti, de Kooning, Rothko and Jasper Johns, and as new generations arose he extended his authority to promoting rising stars such as Rachel Whiteread. He combined a serious

and thoughtful approach with a flair for describing and explaining avant-garde art to general readers. He published several books about Bacon and other artists, made TV programmes, curated numerous exhibitions and organised shows in Brussels, Paris, New York, Houston and Chicago. His work as a champion of contemporary art was finally honoured in 1993, when he won a Golden Lion at the Venice Biennale – the first time the award was given to a critic rather than an artist.

Other critics concern themselves more with the general development of their art and take up a moral or political position on an issue that matters to them. Sometimes a cause will present itself without you looking for it. You may even be asked to lend your weight to a campaign by an artist who is joining issue with detractors and wants to gather support. If you believe in their work, there is every reason to become their champion. Great reviewing is about passion and commitment, not compromise and neutrality.

V IS FOR VENDETTA

This is the negative face of commitment – and many a critic made a great reputation with a vendetta. Everything we have observed about harsh reviews holds good for criticism that is sustained over weeks, or even years, but there are added dimensions to consider. One bad notice adds spice to your writing and weight to your reputation; many bad notices can work the opposite way, boring your reader and making you seem casually destructive and ignorant. The great critical vendettas are always more complex than a mere succession of pannings. In a curious way, a critical vendetta is so bad that it's almost good.

Perhaps vendetta, in the sense of serial revenge killings going on for centuries, isn't quite the right expression. After all, if a critic worthy of respect damned a work in good faith, that work might be expected to suffer in consequence. The best kind of critical vendetta is something deliberately blunted or botched; there is no real malice in it; as a result, the reader is amused but the work is unscathed.

Harold Schonberg of the *New York Times* never understood what most of his contemporaries saw in Leonard Bernstein and attacked his work all through his golden years. 'He was never more readable than when utterly wrong. His verdicts became, in time, immaterial,' wrote his admirer, Norman Lebrecht. Clive James built his popular reputation as the *Observer*'s television critic on a long-running love-hate relationship with the dominant soap of the 1980s, *Dallas*. His parodies of the Texan accents and his assertion that Lucy Ewing had no neck became in-jokes that gave pleasure to – probably not millions, as his newspaper's readership features quality of mind rather than vulgar numbers – but definitely hundreds of thousands.

When you are building a fan-base, your writing becomes a relationship rather than a random seduction and the quality of flow becomes important. The familiarity of your opinions in itself becomes a reason why readers enjoy your work. They turn to your column with the expectation that you will exceed your previous best in witty disapproval. This will hold good even if they disagree with you. Readers are far more sophisticated than many editors believe, and will enjoy a scintillating opinion whether or not they share it.

There are ways to safely pursue a vendetta and choosing foreign product is one of them. James, an Australian who was writing in Britain about a US TV series, was unlikely ever to meet the producers at a dinner party. What happened was that his trashing of the show soon became part of its profile – the fact that this low-culture artefact could attract the sustained attention of a highbrow critic simply added to its stature. James is now a must-have interview on *Dallas* tribute documentaries.

8. NOT A GOOD LOOK

As you should understand too well by now, reviews are often written under pressure. This is no excuse for laziness, lack of professionalism or bad writing, but under pressure a reviewer can fall prey to those things. This chapter deals with some common faults in review writing; you'll find them in your first drafts often, because that's what first drafts are for – finding your weak spots and giving you the opportunity to improve them.

TOO MUCH INFORMATION

You're so bursting with facts and so short of space that you've slapped them all together in a great stodgy fruitcake of a paragraph that most of your readers will be unable to digest.

Here, from *Rolling Stone*, is a movie review that illustrates the phenomenon.

> If you're not hot for Harry onscreen, watch out for *Harry Potter and the Order of the Phoenix*, the fifth of the seven Potter books to be filmed to date. It will hook you good and keep you riveted. The candyass aspect of the first two films – *Harry Potter and the Sorcerer's Stone* in 2001 and *Harry Potter and the Chamber of Secrets* a year later – was replaced by heat and resonance with 2004's *Harry*

Potter and the Prisoner of Azkaban when Mexican master Alfonso Cuaron (*Children of Men*) took over the directing reigns from the prosaic Chris Columbus. Director Mike Newell held the line in 2005's *Harry Potter and the Goblet of Fire*. But it's the lesser known David Yates, behind such British TV dramas as *Sex Traffic* and *State of Play*, who truly raises the bar with this fifth installment.

There was no need to machine-gun the readers with numbers, names and titles like that. Nobody wants to know about the credits of the director of the movie before the movie you're actually writing about. All that the reader wants to know from a small preview notice such as this is, 'Do I want to see the film?' Given the extraordinary global cult that is Potter, the answer was a predetermined 'yes' anyway. The reviewer could have used the same number of words to describe just what he found uniquely wonderful about David Yates's interpretation of the story and written something that was both more readable and more useful.

GOING GONZO

Gonzo journalism was the name that Hunter S Thompson gave to his own style of reporting, a style that overturned the objective, respectful, ponderously authoritative ideals of mainstream American writing in the post-World War Two decades and ushered in the partisan, poetic and experiential style that revitalised journalistic writing around the world and allowed print media to reposition themselves for combat with television. Thompson's keynote gonzo report, *Fear & Loathing in Las Vegas*, was published in *Rolling Stone* magazine in 1972 and gave as much attention to the effects of the drugs under which it was written as to the political rally which was its subject.

This noble, inspired and iconoclastic spirit belonged to its times. Gonzo was great in the last century but now it just looks immature. Reviewers who waste words on issues such as whether they got lost

on the way to the gig or how outrageous the bar prices were represent the sad echo of gonzo writing and should get over themselves. You're not there for the beer. You're there for the work, and nobody cares what you think about anything else. Okay, if one of the great arts venues of the world has just re-opened after refurbishment you can give that a few lines, but otherwise – stick to the main event.

AD GLIB

Glib judgments sound great when you write them but they look terrible in print. Being glib, which means 'fluent in a superficial or insincere way' is another product of having too great a sense of power and status. You start feeling omnipotent and then make judgements that are plain silly, or, worse, silly and offensive. These judgements are highly likely to get up the nose of any reader with two brain cells in connection, who may express feelings like those of this writer:

> Michiko Kakutani's review of Dave Eggers' latest novel, *You Shall Know Our Velocity*, is a good review by the standard measure — well-written, entertaining, knowledgeable and thorough.
>
> But whatever its value (and it does have real value, I think), there's a line in it that betrays its flaw (a flaw that's quite deep, as has been said elsewhere): 'Sometimes moving, sometimes funny but more often haphazard,' Kakutani writes, 'Velocity is clearly the work of a talented writer cruising along on automatic pilot.'
>
> However insightful her comments on the work itself, her review only suffers from its apparently presuming to understand the author himself and what he put into his writing. Kakutani can't possibly know such things (of course), and that she would write as if she did — and so glibly, too! — robs her work of any genuine subtlety or understanding it might otherwise have displayed.
>
> Of course, it's not hard to guess why a writer might include a remark like that, despite the disservice it does the reader. It's much easier to write an entertaining review if the reviewer doesn't let

legitimate complexities and unknowables interfere with his or her wit, and just spews out whatever clever pithicism he happens to invent without bothering to wonder if it's really at the heart of anything. I mean, clearly, Kakutani knows a lot about writing on autopilot herself; it's not like she did any more than let her own talents cook up their own empty display for this review.

Ouch! This isn't a well-composed comment by any standards; the original had five passages in parentheses in four short paragraphs, which is five too many. It's arguably wrong, since, after almost a quarter of a century of reviewing for the *New York Times* and a Pulitzer Prize in 1998, Kakutani might well know a cruising literary luvvie when she reads one. It was her tone that annoyed this anonymous blogger; who lashed out in severe irritation – what you invite when you start to sound glib. That said, Kakutani's professional persona has an element of considered cruelty. She has played very effectively against the expectation that a woman writer should be emollient and her taste for controversy has enhanced her standing.

Just ask yourself if you're making judgements from the standpoint of honest, solid and earned authority or simply to make yourself sound clever. And try not to deliver opinions on matters about which you can't possibly know the facts.

William Hazlitt, the leading critic of nineteenth-century England, called the habit of giving ignorant opinions ultracrepidarianism; he derived the term from a Latin proverb, 'Ne ultra crepidam judicaret', meaning that a shoemaker should not judge matters beyond his own soles.

Criticism sometimes creates its own problems. Reading criticism engenders a judgemental frame of mind, which makes readers excessively irritable. If you want to deliver an opinion on something of which you do, in fact, have surprising knowledge, knowledge that your readers and your editor may not realise you enjoy, make it clear how you acquired your information – *'writing from the standpoint of a former*

major in the Blues and Royals, I found the descriptions of Army life as cliched and unconvincing as...'

GIVING AWAY THE ENDING

The pits of unprofessionalism – never do it. (Unless you're writing for a magazine such as *Sight & Sound*.)

VULGAR ABUSE

Apart from the possibility that it will land you in court, terminate your career and liquidate your assets, vulgar abuse will simply demonstrate your ignorance. Vulgar abuse takes two principal forms – *ad hominem* attacks and ignorant rants.

An *ad hominem* attack is a criticism which blames an artist for a personal quality and not for a deficiency of their work – saying that an actress has a backside the size of Mongolia is a personal insult when you could more accurately observe that casting a Rubensesque actress in the role of a concentration-camp inmate did nothing for the dramatic truth of the play. There are sometimes fine lines to tread here. When he began his career the violin virtuoso Nigel Kennedy was savagely criticised for giving concerts wearing exotic silk waistcoats rather than the traditional evening dress. His reviews would have more to say about the waistcoat than the performance. It quickly became obvious, however, that here was one of the greatest players of our age and after a few years the critics who had damned him for attention-getting dress realised they looked stupid and desisted.

Ignorant ranting involves an intemperate judgement that is mistaken. It shows that you're an amateur and arrogant with that. You've skimped preparation, gone light on research and you think you can tell the world how things are and have the world believe you. You can't. They'll just stop reading and they may even write to your editor and tell him how stupid you are. So if you want to highlight an

aspect of a work that you found less than satisfactory, make sure you know why it was executed that way and who you should be blaming for it. In collaborative arts like music and drama it's easy to blame a cinematographer for a director's choice, or a writer for a line that an actor rewrote, or a soloist for a tempo that the conductor imposed. Take care to criticise the fault without attributing the blame wrongly in ignorance.

9. A CRITICAL TIMELINE

When the arts began their audiences were small groups and the artists – the storytellers, the ritual performers and the people whose hands painted the cave walls at Lascaux or moulded the Venus of Willendorf – were part of their communities. Creative work was part of religious practice and community life. Maybe somebody travelled from one settlement to another in Ancient Greece and mentioned that it was really worth a day's hike to hear that Homer person telling the story of the siege of Troy.

Settlements became villages, villages became towns, towns became city states. People built temples adorned with painting and sculpture, people built theatres and the arts began to play different roles in human lives – spiritual, cultural, decoration, entertainment. Figures who embodied or inspired creative work, like the Muses of Ancient Greece or the Asparases of India, appeared in the pantheons of Indo-European peoples.

In Ancient Greece intellectuals began to discuss the arts and develop principles of aesthetics, to define good and bad creative work and analyse its production. Much of this discourse was oral and can only be guessed at. Of the works which have been written down and so survive to the present day, Aristotle's *Poetics* recognisably begins to define critical principles. 'I propose to treat of poetry in itself and of its various kinds, noting the essential quality of each,' he begins. 'To

inquire into the structure of the plot as requisite to a good poem; into the number and nature of the parts of which a poem is composed; and similarly into whatever else falls within the same inquiry.'

THE FIRST CRITIC

The arts and religion remained closely related. The primary purpose of art, whether an icon in a church or a play performed on market day was to communicate to a population which was largely illiterate. The songs of the troubadours or the texts written by the educated elite carried on the intellectual discourse that remained comprehensible only to a tiny minority.

The concept of artistic achievement for its own sake emerged in Europe in the Renaissance, part of the great fusion of thought, knowledge and technology that produced an extraordinary flowering of culture. The invention of the printing press, which made texts easy to reproduce and so widely available, was central to these advances and also to the birth of the critic. For the first time the evaluation of art by an individual with specialised knowledge and informed judgement was in itself a valuable cultural work.

The first critic in Europe, who has been referred to by some of the writers quoted in this work, is recognised as Giorgio Vasari, who was born in the beautiful Tuscan hill-town of Arezzo in 1511. He was a child prodigy, both in drawing and in scholarship, and was apprenticed to a great painter and distant cousin, Luca Signorelli, whose Last Judgement can be seen in Orvieto cathedral. As a gifted young painter, he moved to Florence, where he joined the studio of his hero, Michelangelo.

A few years later Vasari moved on to Rome, where, in a historic conversation that has shaped our concept of art, Cardinal Farnese suggested that he should write a book about the artists of their time. Vasari's collected biography, *Le Vite delle più eccellenti pittori, sculto-ri, ed architettori (Lives of the Most Excellent Painters, Sculptors and Architects)* appeared in 1550 and is scholarly, personal, comprehen-

sive, anecdotal and also critical; it remains the most important record of the greatest epoch of the world's art. He dedicated it to the ruler of Florence and the patron of the greatest artists of the era, Cosimo de' Medici. Such dedications were intelligent applications for patronage at that time; this one was successful and Vasari was employed by Medici from 1553 to the end of his life.

As both painter and architect, Vasari was accomplished but not a genius on the scale of those whose lives he recorded. His paintings are in galleries all over Europe and his frescoes and architecture can be seen in the Sala Regia at Rome, the cathedral, the Church of Santa Maria Novella and the Uffizi Palace in Florence. Above his own art, however, he is honoured as a witness to his extraordinary times and associates, and as an appreciator of their achievements. It is possible to trace Vasari's judgement in every subsequent critique of the key works of Renaissance Italy. Here, for example, is his description of the Mona Lisa.

For Francesco del Giocondo, Leonardo agreed to paint the portrait of Mona Lisa, his wife; after working on it for four years, he left it unfinished; and the work is now in the collection of King Francis of France, at Fontainebleau. Anyone wanting to see how realistic art could be will find an ample demonstration in this head. In it were reproduced all the subtle details that can be painted. The eyes had that lustre and watery sheen which are always seen in life ... The mouth, half-open and with its ends united by the red of the lips to the flesh-tints of the face, truly seemed to be not paint but flesh. In the pit of the throat, if you looked carefully, you could see the pulse beating. The head was painted so well that any other great painter, whoever he might be, would tremble and despair. He made use, also, of this device: Mona Lisa being very beautiful, while he was painting her portrait Leonardo always employed people to play or sing, and jesters to make her laugh, in order to take away the sad look which painters often give to their portraits. And in this work of Leonardo's there was a smile so pleasing, that it was a thing more

divine than human and it was held to be something marvellous, since the real woman hardly looked more alive.[27]

THE PRESS EVOLVES

Printing developed quickly; in Vasari's time state information, formerly conveyed by town criers and official messengers, began to be communicated in official notices. Nothing could control or suppress the proliferation of street media and little hand-cranked presses could hardly produce pamphlets, songs, poems and sermons fast enough. While diplomats and private individuals continued to send news to each other in handwritten letters, printed news-sheets appeared to make news publicly available. One of the earliest in London was the *Corrant Out of Italy, Germany etc*, which kept English readers up to date with events in mainland Europe.

By 1700, England had newspapers, printed under official licence, in most big towns. Coffee houses, a concept imported from the Eastern Mediterranean, became fashionable at the same time and soon every educated man – women weren't welcome – could spend most of the day reading and debating the ideas of the day in like-minded company with food, beverages, newspapers and books on hand. Books and plays were reviewed and these notices considered part of the news of the day. By 1779, the play *The Critic* by Richard Brinsley Sheridan could depict the life of a theatre critic as something the audience would easily understand, and his description suggests that the role has not changed much since that time. In this scene, the critic of the title, Mr Dangle, is sitting with his wife at breakfast, reading the papers and being affectionately abused for boring her and filling the house with aspiring actresses. She starts after he throws aside a political paper and looks for one with theatre news, complaining:

> MR DANGLE. *I hate all politics but theatrical politics. Where's the Morning Chronicle? ... So, here we have it. [Reads.] 'Theatrical*

intelligence extraordinary: We hear there is a new tragedy in re-
hearsal at Drury Lane Theatre, called The Spanish Armada, said
to be written by Mr. Puff, a gentleman well-known in the theatrical
world. If we may allow ourselves to give credit to the report of the
performers, who, truth to say, are in general but indifferent judges,
this piece abounds with the most striking and received beauties of
modern composition.' So! I am very glad my friend Puff's tragedy is
in such forwardness.

MRS DANGLE. Lord, Mr. Dangle, why will you plague me about
such nonsense? Now the plays are begun I shall have no peace. ...
Why should you affect the character of a critic? I have no patience
with you! Haven't you made yourself the jest of all your acquain-
tance by your interference in matters where you have no business?
... You have contrived to get a share in all the plague and trouble
of theatrical property, without the profit, or even the credit of the
abuse that attends it.

MR DANGLE. I am sure, Mrs. Dangle, you are no loser by it, ...
Didn't my friend, Mr. Smatter, dedicate his last farce to you at my
particular request?

MRS DANGLE. Yes; but wasn't the farce damned, Mr. Dangle? And
to be sure it is extremely pleasant to have one's house made the
motley rendezvous of all the lackeys of literature; the very high
'Change of trading authors and jobbing critics! Yes, my drawing-
room is an absolute register-office for candidate actors, and poets
without character. Then to be continually alarmed with misses and
ma'ams piping hysteric changes on Juliets and Dorindas, Pollys
and Ophelias; and the very furniture trembling at the probationary
starts and unprovoked rants of would-be Richards and Hamlets!
And what is worse than all, now that the manager has monopolized
the Opera House, haven't we the signors and signoras calling here,
sliding their smooth semibreves, and gargling glib divisions in their
outlandish throats. With foreign emissaries and French spies, for
aught I know, disguised like fiddlers and figure dancers?

> MR DANGLE. *Mercy! Mrs. Dangle! ... it does not signify. I say the stage is the mirror of Nature, and the actors are the Abstract and brief Chronicles of the Time: and pray what can a man of sense study better? Besides, you will not easily persuade me that there is no credit or importance in being at the head of a band of critics, who take upon them to decide for the whole town, whose opinion and patronage all writers solicit, and whose recommendation no manager dares refuse.*

THE CRITICAL MUSE

Gradually liberated from both censorship and taxation, the press in Europe was empowered by industrialisation which both made printing on a large scale possible and provided a large, geographically concentrated readership. Newspaper circulation rose to tens of thousands and critics became more and more influential. At the turn of the nineteenth century a young journalist, William Hazlitt, having decided to give up painting and concentrate on literature, was becoming a friend of the leading writers of his time. He wrote essays on drama and literature, contributed reviews to leading newspapers and then followed Vasari by writing *The Spirit of the Age* (1825), an appreciation of his artistic contemporaries, including Charles Lamb, Samuel Taylor Coleridge, William Wordsworth, Lord Byron, Jeremy Bentham and Sir Walter Scott

The radical passion of Hazlitt's youth, when his admiration for Napoleon was highly controversial, never died down. As his interests broadened he began to consider politics more important than art and to criticise writers he formerly admired for, as he saw it, betraying their humanist and revolutionary ideals. He then fell in love with a maid at the lodging house where he lived and published their love letters, which provoked a scandal that ended his journalistic career.

Hazlitt was the precursor of the great nineteenth-century critics who were central to the development of major artistic movements. Three figures tower above the many writers who took part in the process: Charles Augustin Sainte-Beuve in France, Matthew Arnold and

John Ruskin in England. Arnold, both poet and critic, first defined criticism as an art form in a series of essays published as *The Function of Criticism* in 1865. Sainte-Beuve, born in Boulogne in 1804, became a doctor but practised medicine for only a year before his literary work overtook his life. He wrote reviews for a Paris newspaper, *The Globe*. An appreciation of Victor Hugo's poetry led to a friendship with the poet, an affair with his wife and entry into the Cenacle, a new literary coterie who sought to revive the romantic, royalist traditions of writing. Members, at various times, included Alfred de Musset, Prosper Mérimée, Alexandre Dumas père and Théophile Gautier.

Erudite, sociable, volatile, and loyal to a fault, Sainte-Beuve was sometimes too diplomatic for his own good. Among his friends were the brothers Edmond and Jules Goncourt, who wrote a novel, *Madame Gervaisais*, which he reviewed kindly but criticised in private. The Goncourt brothers accused him of a lack of integrity and ended their friendship.

Sainte-Beuve described his work as a series of campaigns. He believed in free speech, in freedom of the press and, most crucially, in considering art and artist as one, never judging the art without considering the man. This led him into a famous dispute with a young literary critic, Marcel Proust, who rebutted the concept in a series of essays that eventually led to his novel cycle *À La Recherche du Temps Perdu*.

Proust's greatest influence was the English critic John Ruskin; he said he knew several of Ruskin's works by heart and wanted to produce a French translation of them. Ruskin, a prodigy, a polymath and the inspiration for the art of his times and for many institutions in British life, defined an entire philosophy of the arts in his 250 published works. An artist, writer, scientist, poet, philosopher, social and environmental campaigner, he was born in London in 1819, educated at home and accepted by Christ Church College, Oxford, on the strength of his poetry.

While he was still a student, Ruskin began to contribute to architectural magazines, writing in praise of English vernacular architecture.

His stature as a critic was confirmed when the first volume of *Modern Painters* was published in 1843. In it he championed Turner, whose later paintings were under attack for their semi-abstract style. Ruskin praised him for pursuing the truth of nature in his work. Critic and artist were already friends and Ruskin eventually became Turner's executor.

Ruskin's ideals embody Victorian England at its most compassionate. Always searching for an artist's moral philosophy, he believed that 'All great art is the work of the whole living creature, body and soul, and chiefly of the soul'. He championed the Pre-Raphaelites for their ideals of naturalism and their romantic pre-socialism, writing to *The Times* in 1851 that they could 'lay the foundation of a school of art nobler than the world has seen for 300 years'.

His attention turned naturally to politics and social reform; he gave away his inherited wealth, founded an art college, and many cultural or educational charities. His inspiration was significant in the development of institutions as diverse as the Arts & Crafts Movement, the National Trust and the Labour Party. He has given his name to an architectural style, Ruskinian Gothic, and Ruskin College in Oxford. His emotional life was unhappy, his health was poor and his spiritual existence sometimes tortured. In later life his judgement failed and he was eventually sued for libel by a rising painter, James McNeil Whistler, whose work he attacked in almost the same terms as Turner's critics had used 40 years earlier. It was another defamation case in which the judge found for the plaintiff but awarded costs in favour of the defendant. Ruskin spent his last years in the Lake District, English romanticism's spiritual home, and his influence on British cultural life is still strong.

A WONDERFUL TOWN

In evaluating criticism in Europe in the twentieth century, the most significant influence is not that of any artistic movement but the all-consuming trauma of two World Wars. So many artists and writers

died that those who were left seem, understandably, to have lost confidence in the importance of their work.

After the creative earthquakes of the early twentieth century, when cubists, surrealists, expressionists and modernists overturned every accepted concept of art, critics, even those of distinguished achievement themselves, either recoiled or hurled themselves into the revolution and became practitioners overnight. Jean Cocteau, an entranced witness to the Ballets Russes season in Paris, willingly took up the challenge from their impresario, Serge Diaghilev, to 'astonish me', began a creative life that spanned plays and films as well as a ballet libretto. Other writers were wrong-footed. George Bernard Shaw called James Joyce's *Ulysses* 'a revolting record of a disgusting phase of civilisation'. It was an era in which the avant-garde swept all before it with little critical assistance.

The critics of the first half of the century did not lack social conscience but were short of self-belief. Many felt they were marking time and with hindsight their ambitions seem modest. To be working at all was a blessing in the Depression years of the 1930s and it is perhaps understandable that memorable critics of this era gained their reputations for their wit rather than their political muscle.

In New York in 1917, a young writer got a job as an editorial assistant on *Vogue* magazine, which shared an editor with *Vanity Fair*. He appointed her as that magazine's drama critic, at first as a temporary substitute for their resident reviewer, PG Wodehouse, the creator of the Jeeves stories. Dorothy Parker had been born just outside New York in 1893 as Dorothy Rothschild, though to a rag-trade family not the famous banking clan. She was an orphan: by the time she was 20 she had lost her mother, father, stepmother and uncle. Her first marriage lasted two years and her dating misadventures formed a basis for witty verses until she married again.

With shingled hair, shining humour, fondness for cocktails and a flaunted smoking habit, she embodied the outrageous flappers of the jazz age, which is perhaps why *Vanity Fair* sacked her in another

couple of years. 'Dammit,' she said in a later interview, 'it *was* the twenties and we had to be smarty – I *wanted* to be cute. That's the terrible thing. I should have had more sense.' Her reviews from this period are elegantly laudatory ('superlatives are tiresome reading') or, at worst, thoughtfully critical, so it's hard to see what could have been wrong with her work. However, she had met other writers – including Robert Benchley and Robert E Sherwood, who resigned from *Vanity Fair* in protest at her sacking, as well as Franklin Pierce Adams, Alexander Woollcott (who first declared 'All the things I really like to do are either immoral, illegal, or fattening') and one of Woollcott's wartime comrades, Harold Ross.

Many of them had gathered at the Algonquin Hotel for lunch to celebrate a colleague's promotion, and then continued to lunch there, and become the famous Algonquin Round Table, also known as the Vicious Circle. So in 1925, when Ross launched *The New Yorker*, a new magazine for the new era, confident in its metropolitan tone and appealing to educated and sophisticated readers, he naturally hired them all. To this day, they define many aspects of New York culture and their legacy extends to writers such as Jay McInerney and Tom Wolfe. Parker's short story, *Big Blonde*, won the O Henry award for the best short story of 1929; its similarity in tone and subject to the stories of *Sex and the City*'s writer Candace Bushnell is striking.

When *The Paris Review* interviewed Parker in 1956, she played down her role in the Round Table and said she was only present at a handful of occasions. The group was never formally organised and sounds exactly like the loose, companionable associations that critics fall into as they meet professionally several times a week.

Parker married again in 1934, the actor and screenwriter Alan Campbell. With him, and several other Algonquin regulars, she moved to Hollywood and earned a handsome salary. It must be remembered that at that time California was not a cultural desert where one's brain turned to orange juice but a creative crucible where many of the greatest European talents had arrived to make new lives. Her 15

screenwriting credits included the Oscar-nominated 1937 *A Star is Born* and Alfred Hitchcock's *Saboteur*.

Her commitment to left-wing politics was evident from her *Vanity Fair* days and saw her blacklisted in the McCarthy era of the 1950s. Perhaps her personal fight against poverty, prejudice and social injustice seemed more important than any cause in the arts. She continued to review books in her Hollywood years, and returned to New York after her husband died in 1963. There she died of a heart attack in 1967 and left her estate to the Dr Martin Luther King Jr Foundation, from which it passed to the National Association for the Advancement of Coloured People. They created a memorial garden for her ashes with an epitaph which begins: Here lie the ashes of Dorothy Parker (1893–1967) humorist, writer, critic. Defender of human and civil rights. For her epitaph she suggested, 'Excuse my dust'. This memorial garden is dedicated to her noble spirit.

MAKING NEW WAVES

The effect of the two World Wards, 1914–1918 and 1939–1945, was to devastate countries, destroy cities and kill millions in Europe. In peace time the arts were consumed by a sad faux-nostalgia, a longing for simple morality and bourgeois calm. It took 20 years or more for the memory of terror to fade and an iconoclastic new generation to emerge, and this time critics led the revolution.

Films were not art until filmmakers declared that they were. When a new film magazine appeared in Paris in April, 1951, film, in the minds of most editors, was a vulgar popular entertainment, briefly useful as wartime propaganda but now a diversion for factory workers. Students at Trinity College, Dublin, would dust themselves with insecticide to repel the fleas that infested cinemas in their city.

Les Cahiers du Cinéma (*Cinema Notebooks*) was a magazine founded by a triumvirate of film critics including the most influential,

André Bazin, for the members of Paris's tiny art-film clubs. It was then a small-format magazine with a garish, yellow-bordered cover that stood out on the news-stands. Its first years were intelligent but unremarkable.

Then, in 1954, an article appeared under the title *The French Quality* by a writer called François Truffaut, a film-obsessed 19-year-old gang member who had narrowly escaped prosecution as an army deserter. He attacked the traditional, self-congratulatory comedies of 'Dad's Cinema' and praised Hollywood directors like Alfred Hitchcock, Howard Hawks, Robert Aldrich, Nicholas Ray, Fritz Lang and Anthony Mann for their artistic integrity. Truffaut proposed the idea of auterism, the conception of the director as a true artist and creator of a film. Other young critics – Jean-Luc Godard, Claude Chabrol, Jacques Rivette and Eric Rohmer – joined the argument, defining the language of film and inventing the basic principles of cinema theory. They praised avant-garde and social realist directors outside the US, including Jean Renoir, Roberto Rossellini, Kenji Mizoguchi and Max Ophüls.

They wrote by day and in the evening gathered at screenings at Henri Langlois's Cinémathèque, a Paris art-house dedicated to foreign films which were screened almost at random on the theory that all films deserved to be seen and your response should not be pre-judged by hierarchies imposed on the programme. Truffaut, Godard, Chabrol, Rivette and Rohmer swiftly became directors themselves, the leaders of French New Wave cinema. Truffaut was banned from the Cannes Film Festival as a critic in 1958 and won the Palme D'Or for *Les 400 Coups* the following year. At *Cahiers*, other reviewers took over, writing only about films for which they had a passion. It was normal for the magazine to devote 25 pages to, say, the work of one director.

While some American critics welcomed this blast of new thinking, others alleged, with xenophobia that seems breathtaking today, that the *Cahiers* writers only admired Hollywood because they didn't speak English. The idea that their reverence for American cinema was based on not understanding the dialogue was absurd, given that subtitling

was normal at the time. Their style was full of Gallic hyperbole – Bazin once compared assessing a cowboy film to wine-tasting: 'The wine-lover alone can discern the body and the bouquet, the alcohol content and the fruitiness, and all these nuances intermingled, where the uninitiated can only make a rough guess at whether it is a Burgundy or a Bordeaux.'

As years unrolled the magazine became absurd and then chaotic, descending into Maoism in the 1970s before a decorous renaissance. Today, *Les Cahiers du Cinéma* is neither influential nor ground-breaking, just the film supplement of *Le Monde* newspaper, civilised, thoughtful and tame, enjoying the status of a new art for which its first editions fought so hard.

MORE POWER TO THE PEOPLE

Cahiers lampooned British filmmakers; British critical culture did not engage with the cinema in the post-war era. Instead, the action was in the theatre, an art becoming moribund in France. One figure dominated the field – Kenneth Tynan. With uncharacteristic modesty he once described a critic as 'a man who knows the way but can't drive the car'.

He made meteoric early progress from a brilliant boy at a public school in Birmingham ('a cemetery without walls') to a star student at Oxford who entertained celebrity guests in his rooms, a writer who was mentored by the *Sunday Times'* critic Harold Hobson. After graduation he worked unsuccessfully in small theatres and as a director but found his métier when he joined London's *Evening Standard* even before graduating. In 1954, as we noted earlier, he moved to the *Observer* and swiftly became a dominating figure in British artistic life. He first attacked what he called the 'Loamshire' plays of the period, pedestrian drawing-room comedies, 'a glibly codified fairy-tale world of no more use to the student of life than a doll's house would be to a student of town-planning'.

The realism he craved swiftly arrived in the extraordinary year that began in mid-1955 and saw the London premieres of *Waiting for Godot*, *Look Back in Anger* and *The Quare Fellow* followed by the Berliner Ensemble with a three-play Brecht season. Scenting 'the smell of life', Tynan instantly championed new drama that investigated social injustice and human pain. He reviewed for 18 years and during that time also developed a close, almost filial, relationship with Sir Laurence Olivier, the actor he admired above all others.

Tynan attacked state censorship of the arts and hurled himself into the campaign to found the National Theatre with Olivier as its head. When public funding was withdrawn from the project, he and friends dressed as Victorian undertakers with crape-banded top hats, organised a photocall and stood in mourning beside a coffin at the proposed site on the South Bank. Their activism worked, and when the institution was born Tynan quit reviewing to become its literary manager. In that role he was described as the most influential figure in theatre anywhere in the world.

He left in 1973, moved to California and died seven years later at the age of 53. In his final years, suffering from lung disease made worse by smoking, his judgement seemed to desert him, at least in his own endeavours, which were largely rationalisations for his interest in eroticism and pornography. His writing now seems overblown and mannered. At a distance of time, his gift of vivid description, which his contemporaries said made you feel you had seen the performances he described, is hard to appreciate. His influence on modern theatre, however, is lasting and beyond doubt.

LOSING IT AT THE MOVIES

America's most influential film critic despised the auteur theory. In her celebrated attack on new cinema theory, Pauline Kael demanded: 'Can we conclude that, in England and the United States, the auteur theory is an attempt by adult males to justify staying inside the small

range of experience of their boyhood and adolescence – that period when masculinity looked so great and important but art was something talked about by poseurs and phonies and sensitive-feminine types?'[28]

Kael's judgement was independent going on eccentric, although whatever her opinion she expressed it with passion, scholarship and wit. She also said of herself, 'I have a real gift for effrontery – I think it may be my best talent'. The golden period of her writing lasted from 1968 to 1991 when she wrote for *The New Yorker*, by then a staid magazine whose editor, William Shawn, hired Kael with the promise to allow her passionately opinionated style full rein then immediately went back on his word.

This appointment was offered to her at the age of almost 50. The daughter of poor Polish immigrant farmers, she grew up in California, studied philosophy and the arts at UC Berkeley but never graduated because she could not afford the $35 graduation fee. Her love of film was something first shared with her father and then with a circle of avant-garde artists and directors. She wrote programme notes and reviews, beginning with fringe magazines and progressing to the mainstream, working hard to achieve a bright, energetic, colloquial style at odds with the ponderous tracts delivered by the leading reviewers of the day. 'I wanted sentences to breathe,' she said, 'to have the sound of the human voice.'

Success took its time, but by the early 60s she was writing for *McCalls*, a magazine with a big circulation and a low opinion of its readers' intelligence. Kael once said they sacked her for panning *The Sound of Music*, which she called The Sound of Money, but the editor later protested that she was down on so many commercial films that he fired her some months later.

At *The New Yorker*, William Shawn was captivated by her passion for a Jean-Luc Godard film. Over the next 20 years she was to champion Francis Ford Coppola, Steven Spielberg, Brian De Palma and Robert Altman, fall out with Warren Beatty and Woody Allen, defect

briefly to Hollywood to work as a consultant at Paramount and admire a highly personal selection of films that included *Bonnie & Clyde* and *Last Tango In Paris*. Her work was published in a series of ten award-winning books and her critical essays launched debates that continue today; she believed that violent films brutalised public sensibilities and that television damaged the narrative instinct.

Although in her early career Kael had made films, written plays and managed a cinema, the magic note in her critical voice, the factor that for years made her section of the magazine the best-read, was her robust identification with the ordinary cinema lover. Her thoughtfulness and scholarship were always evident, her style was never as conversational as Dorothy Parker's was, but her heart seemed to beat like every other heart in a dark auditorium. The announcement of her retirement was described as earth-shattering.

UNDERGROUND OVERGROUND

The cultural revolution of the late 1960s created its own media, the scintillatingly written, smudgily printed and exuberantly designed 'underground' newspapers like *Crawdaddy!*, *International Times* and *Oz*. Hand-sold in Haight-Ashbury and Portobello Road, produced on equipment 'liberated' from the straight workplaces its editors hoped to forsake, and financed in some cases by moonlight flits and selling drugs, these publications created a wild new school of journalism which went mainstream in 1967 when Jann Wenner, three years out of high school, and veteran jazz writer Ralph Gleason founded *Rolling Stone* magazine.

Founded as a music paper, *Rolling Stone* immediately became the voice of the counter-culture and developed by fusing the high professional standards of the established press with the anarchic spirit and populist openness of the underground. Early editions carried an appeal for any reader who thought they could write to submit articles, a strategy that brought Greil Marcus and Lester Bangs into the fold.

Marcus, now a distinguished cultural commentator, became reviews editor at a salary of $30 a week; Lester Bangs, who he considered the greatest writer in America at that time, lasted hardly five years at *Rolling Stone*. He was an aggressive interviewer and savage critic, a stance that was perhaps too extreme to support Wenner's high ambitions for the magazine. He died of an accidental overdose of medical drugs in 1973 but remains a dominating influence in rock writing. 'By profession, I am categorized as a rock critic. I'll accept that, especially since the whole notion that someone has a 'career' instead of just doing whatever you feel like doing at any given time has always amused me when it didn't make me wanna vomit. O.K., I'm a rock critic. I also write and record music. I write poetry, fiction, straight journalism, unstraight journalism, beatnik drivel, mortifying love letters, death threats to white jazz critics signed 'The Mau Maus of East Harlem,' and once a year my own obituary (latest entry: 'He was promising...'). The point is that I have no idea what kind of a writer I am, except that I do know that I'm good and lots of people read whatever it is I do, and I like it that way.'[29]

Wenner's vision for the magazine always embraced the wider culture and a political discourse. *Rolling Stone* moved to New York in 1970, attracting its keynote contributors including Hunter S Thompson, Tom Wolfe and Annie Liebowitz. Another alumnus, Cameron Crowe, recorded his experiences as a young rock writer in the film *Almost Famous*. Since its heyday the magazine has survived two periods of readership decline and recently re-positioned itself as a competitor in the glossy, celebrity-driven Noughties youth culture.

LOW CULTURE FOR HIGHBROWS

The concept of *The Modern Review*, the magazine that transformed arts reviewing in Britain in the 1990s, was born when three young arts writers spent a day at a tacky amusement park in the London suburbs. Toby Young, Cosmo Landesman and Landesman's then wife,

Julie Burchill, went to Thorpe Park. 'Sixteen years ago,' Young recalls, ' I got together with a group of like-minded friends and started a magazine called *The Modern Review*. Its premise was that popular culture is as worthy of serious critical attention as high culture and, to that end, we commissioned intellectuals and academics to write about the likes of Madonna and Arnold Schwarzenegger. Believe it or not, this was a fairly radical idea back in 1991 — though not a wholly original one — and the magazine caused quite a stir. The previous generation of writers and critics attacked us on an almost weekly basis.'

To literature, at least, the idea was new. Britain's literary elite still wore tweed jackets and refused to read paperbacks. Martin Amis's definition of popular culture as 'the moronic inferno' suited the elitist cabal in control of British publishing just fine. Their readers had moved on and, with the Internet revolution on the horizon, they were out of contact with the world. Elsewhere in the culture the ideals of *The Modern Review* were already current, especially in television where programmes like *Arena* or *The South Bank Show* were happy to give rock lyrics the same attention as poetry, but since the elite sidelined television they saw nothing to disturb them except falling sales. What remained was to sweep out this old guard whose dead grip was strangling the traditional reaches of the culture.

The magazine's influence came as much from its attitude as its content. Burchill, a compulsively shocking writer, took to the limit the part in the manifesto that insisted, 'Mass culture may offend against good taste ... but that's what's good about it.' A journalist who had started out on music magazines, she fascinated a section of London media, including Young, who describes her then as having 'this almost supernatural ability to produce an endless succession of dazzling one-liners, as if performing an extremely polished stand-up routine. These monologues were funny and insightful and, occasionally, quite cruel. But above all they were impressive. Her mind wasn't trained in any way, but there was no mistaking the raw intellectual candlepower. Later, the director of a documentary about *The Modern Review* said

that Burchill's interest in Young 'seemed largely to be founded on his ability, as a privileged right-winger, to offend her left-wing associates in music and style journalism.'[30]

Iconoclasm was an ideal in itself and the magazine's founders made themselves icons by their relentlessly outrageous pronouncements. 'Who cares what we all think?' said Burchill. 'I'm not putting myself down, but we were just a bunch of very self-important, jumped-up media types that no one had heard of.' 'The whole enterprise was driven by one fairly simple idea,' says Young. 'And that was that critics had a responsibility to take the best popular culture as seriously as the best high culture. It doesn't sound remotely radical now, because the entire broadsheet press is stuffed with Oxbridge graduates writing about *The Terminator*. But in those days, it was a new idea.'

Their principal backer was Peter York, which is the pseudonym of one of Britain's most astute cultural commentators, who had coined the phrase 'Sloane Ranger' for the young, upper-class London girls in the mould of Diana, Princess of Wales and remains a partner in an influential consultancy firm. While Young wrote dazzling copy in the tiny West London office, Burchill held court in Soho at The Groucho Club, attracting a constellation of new talent including Nick Hornby and Will Self as well as big names from the US, notably Pauline Kael and Camille Paglia. They were rarely paid and encouraged to savage each other in print, while a self-indulgent editorial policy inevitably led to declining sales. The magazine lasted twenty issues over four years; Burchill appears to have got bored, fallen out with Young, left her husband, embarked on a relationship with another journalist, Charlotte Raven, and, in general, comprehensively trashed her achievements.

Young edited a finale issue reprising their greatest hits. He told their remaining readers: 'Julie Burchill and I have fallen out and we're bringing our empire down with us.' The mainstream press, notably the *Sunday Times*, where Landesman currently reviews films, had already copied the *The Modern Review*'s stance and poached most of their writers.

10. STARTING OUT

If nothing you have read so far has deterred you, you may be considering a career as a reviewer. If you've read this book with close attention, many of the classic career paths will already be clear to you and you will have learned the best tips that my colleagues and I can offer you to help you manage a glittering career. So this chapter largely formalises this information and attempts to add some essential pointers. Given that you may be considering this career at any time in your life, I've organised the advice appropriate at each stage. The most important thing to understand at the outset is that, whatever your formal qualifications, a visionary editor will hire you if you can write and the media will be impressed more by published work than by any other factor.

SCHOOL

Yes, you can begin here. There is a school magazine. If there isn't, or if the people who run it are obnoxious, start one. Write reviews. See them in print. Save them carefully. These are your very first by-lines and they count.

Plan your exam choices strategically. Somebody who wants to be a journalist should be able to bring an educated mind to the profession. What you study at university can make you more attractive to an editor, especially if it's a subject that offers an enhanced basis

for understanding the world, such as politics, economics, European or American studies, sociology or history. If you are already devoted to one art, consider film studies, drama, music or art history. Ask for advice on the best university courses for these subjects and find out what their entry requirements are. Take the university's student newspaper into consideration and ask them about the leaving destinations of their contributors. The most highly regarded of these are established recruiting grounds for the media.

While you should concentrate your energies on getting the best grades you can in your school exams, see if you can fit in any work experience or holiday job in the media. Network your way around your family, and your friends' families, for people who will recommend you for these placements. A summer spent helping a working journalist or working on a new reviews website will be invaluable. Most people like helping keen students who're eager to get on so don't be afraid to ask.

UNIVERSITY

Undergraduate courses in journalism do exist but, as explained above, you will look more attractive to an editor if you can offer specialist knowledge, especially in the subject you want to review. So for three or four years you can build up a good body of knowledge.

The media recruit young writers in three ways – from postgraduate journalism courses, from student newspapers and from their own interns. So while you're concentrating on your grades, start organising these. Find out what you need to get on the best postgraduate training courses or Masters degrees. Write for your student newspaper, and, again, if it's crap or you don't like the people who run it, start your own. Write for any arts website that you enjoy browsing. And apply for internships from your second year if not earlier. It can take six months for a work-placement to be available and – surprise! – the pressure on them in the university holidays is extreme.

A challenge for would-be reviewers who aren't yet attached to a publication is getting the privileged access to work, the tickets to press nights and private views, the review copies of books and albums. Without this access, your review follows the launch coverage of a work and looks out-of-date. You will need to put in some extra work to get the invitations you need. There is a dispiriting chicken-and-egg area here, in which you can get on press lists if you have a by-lined review to prove your status, but you can't write that review unless you're on a press list.

It may be worth taking a step sideways into the more accessible areas of the arts. For plays and some concert performances, every run will have a designated press night for which any member of the public can buy tickets. For films, many cinemas offer previews to mailing list subscribers, so get your name on those lists. Books, bizarrely, can be offered for sale by dealers on Amazon marketplace before their official publication – don't ask me how, but it happens. At a private art gallery, you can simply drop by at a quiet time and ask to be put on their mailing list. After that you will be invited to private views. So you can achieve a certain level of access just as an ordinary member of the public.

To get the real inside track, however, you need to identify the key gatekeepers and convince them that you have something to offer. You need to find out how to get in touch with the producer, publisher or music company, to track down their press contact and to get yourself on the invitation list in the name of your student newspaper. Just mention the size of the campus – 15,000? 60,000? – and explain that this number represents your readership.

Your university library may well carry the trade press for your art, which will give you lists of upcoming openings or releases. Most of these publications have on-line editions that you can browse with a subscriber's password. If the library doesn't carry these publications, suggest that it should.

POSTGRADUATE

Choose a postgraduate course in journalism that is industry-approved and career oriented. In the UK, look for courses that are endorsed by the NCTJ, the National Council for the Training of Journalists. Investigate the relationship that the course has developed with the media industries; some work very closely with the neighbourhood press and can offer you good experience. The classic progression from a small-town newspaper to the big time still works and your CV will always impress if you've 'earned your stripes'. Don't even think about a part-time mail-order course advertised on the back page of a Sunday newspaper.

FIRST CAREER

So you're an arts practitioner and you want to become a reviewer. You will be bringing special insight to the role and many artists, and arts administrators, have crossed the floor with success. While you are preparing to make your move, you are in an ideal position to make contact with the reviewers in your area, to develop relationships with them, to make your ambition known and to hope that, when they take a holiday, they'll suggest you as their stand-in.

While you're waiting for an opening, see if you can take a postgraduate training course or part-time MA in journalism. Many institutions offer evening or weekend classes which can fit around a full-time job. Some arts, especially dance in which many careers are over after the age of 35, prepare practitioners to move on and you should certainly take advantage of any formal provision there is for retraining. Also investigate your funding options; some arts charities will make career development grants.

It is rare for a complete outsider to be offered a reviewing role, although the film critic of one of London's most respected suburban newspapers is a retired lawyer who left his profession early in order to

establish a writing career. While you are still in your first career, see if any publication related to your profession will offer you the chance to write for them and so acquire the all-important first by-line. Even your neighbourhood e-newsletter may have space for reviews and may be grateful for a volunteer to organise their arts coverage.

HOW TO APPROACH AN EDITOR

Just bear in mind that all editors are busier than God and many have to delete 300 emails every morning. While established reviewers usually communicate by email, if you're looking for a job you will probably have an edge if you send a letter. Consider timing this letter about a month before holiday periods, when it's exceptionally likely that regular reviewers will be away.

Who to approach? A systematic approach will make you feel in control of your destiny and help you deal with rejection if that should be your fate. Make a list of every publication you'd like to work for, prioritise it in your order of preference, and work through, say, six targets a week.

For each publication, accuracy is essential. Find out *exactly* who commissions reviews on the medium you have chosen. In these days of voicemail, that can be difficult. If you've spent a morning talking to electronic voices, try calling the assistant to the section head, or even the editor-in-chief and throwing yourself on their mercy. As a last resort, call the advertising staff, who will certainly answer the phone but may not have an answer for you. But they'll know who to call in editorial. When you have a name and a job title, and you've made sure you've got the right spelling for them, see if you can also find out what time of day is least busy for them.

You need three things to send to a potential editor and they should all be short, polished and brilliant. And also flawless. One spelling mistake reveals a fatal lack of professionalism. Your package will be read in a hurry and the reader will react very quickly to it. The Lester

Bangs approach – his pitch letter to *Rolling Stone* was famously offensive – will work if you're approaching some neo-punk heavy metal journal or any other medium whose editorial style is incandescently transgressive; otherwise be as polite and charming as you can be throughout the entire process. And choose good-quality, plain, white or cream paper and use a font that is conventional (Arial, Verdana, Times Roman) in a size of at least 12pt. Crazies write to the media all the time, in purple ink on paper wreathed in Celtic strapwork. You don't want to look like a crazy.

So your package, probably an A4 envelope, will contain:

1. A letter asking to review for the publication. Half a dozen sentences should do it. In the first sentence explain how great you think the publication is – you have, of course, done your research and will write this with authority without being arrogant, creepy or patronising. 'I'm writing to you because your site carries the most brilliantly written and well-informed film criticism on the web.'

In the second sentence, say what you want to write and how much you'd like to do that. 'I'd love to review films for you,' would cover it. In the third sentence, say who you are, what you've done so far and how you can be contacted. 'I'm finishing my MA in Journalism at Rutland University in September; I've written reviews, features and interviews regularly for our student newspaper, *The Rutter*, and in my first career as a theatre sister I also wrote for *The Nursing Times*. Some samples of my work are enclosed, along with my CV.' Then it's the usual courtesies and your signature.

2. Your CV. Again, keep this as short as you can. Two pages tops. Start with your key skills or attributes for this job: Brilliant writer: MA in Journalism: Popular and Experienced Reviewer: Good Industry Contacts.

Follow with a summary of work or work experience, with the most recent achievements first, and then follow with your education, spe-

cial interests and such personal details as you feel like disclosing. If you're already reviewing, give a contact email or phone number for the person who commissions you.

Try to include something that will give anyone who interviews you something fun to talk about. One of the best CVs I've read – yes, it was professionally edited – included a line mentioning that the subject had helped wash penguins rescued from an oil slick at a wildlife centre in South Africa. It was only a morning of her life, but mentioning it made her seem adventurous, compassionate, imaginative and a good team-worker. All of which she is, but washing penguins sounds so much more interesting than listing those qualities.

3. Samples of your work. Two or three should be enough unless you've been writing very short preview notices. Get fresh colour copies made if the originals are looking a little tired. Put them in a plastic envelope, nothing more elaborate. The pieces should be identified with the date, the name of the publication and, of course, your by-line.

A couple of days after you estimate that your letter has been delivered, call up (if you have a live phone number) or send an email to ask if the editor got the letter and if they'd like to invite you for an interview. Choose a sensitive time to do this, not press day or edition time – that would mean calling on Tuesday for a Sunday newspaper or the morning for a daily.

And – good luck. Luck is what happens when preparation meets opportunity. You can prepare. You can create opportunities. You will be lucky.

APPENDICES

APPENDIX 1

RESEARCH CHECKLISTS

Visual Arts

The artist's previous work
The movement to which it belongs
The background of the galleries or collectors who are exhibiting it
Where did the artist train?
Who taught the artist?
Any statement of philosophy or ambition?
Has this work won an award?
If so, who were the judges and the previous winners?
Who sponsors this award?
What are the technical demands of the artist's chosen medium?

Theatre, Film or Television

Who is the director?
Who are the leading actors?
The writer or writing team?
The cinematographer or cameraman?
The editor?

The art director or designer?
Their influences?
Their previous work?
Their next project?
Major works in the same genre
Background of the producer or commissioning network
Film – how was the production financed?
Where was it shot?
Classical theatre – performance history of the work
Major past interpreters of leading roles

Classical music, opera or ballet

The conductor
The composer and his history
Relationship of composer and conductor or performers
Leading performers
Performance history of the work
Highlights in the performance

Popular music

The major names in this musical genre
The artists and their previous work
Any celebrity or industry gossip?
The latest albums from the performers

Books

Non-fiction:
Major works on the subject
History or background to the subject
Novels:

Author's previous work
Any awards won by the author
Similar work or genre to which the work relates
Literary theory in which the work is relevant

APPENDIX 2 – NOTES

1 Richard Corliss, 'That Wild Old Woman', *Time*, July 11, 1994.

2 Tom Stoppard, Kenneth Tynan, *Theatre Writings*, Nick Hern Books, London 2007.

3 Nancy Banks-Smith, *The Guardian*, July 25, 2003.

4 Norman Lebrecht, 'What Makes A Great Critic', *Scena*, October 2, 2003.

5 Martin Amis, *London Review of Books*, December 1981.

6 Andrew Collins, *That's Me In The Corner: Adventures of an Ordinary Boy in the Celebrity World*, Ebury Press, 2007.

7 Joe Morgenstern, *The Wall Street Journal*, June 25, 2004; Page W1.

8 Robert Christgau, *Book World*, January 7, 1973.

9 Philip French, *The Observer*, August 10, 2003.

10 Michael Coveney, *Prospect*, April 2006.

11 Clive Barnes, *The New York Times*, May 22, 1975.

12 Michael Coveney, op cit.

13 Judith Mackrell, The Guardian Unlimited: Arts blog, January 16, 2007. http://blogs.guardian.co.uk/art/2007/01/up_close_andt_personal_cha.html

14 Jonathan Jones, The Guardian Unlimited: Arts blog, January 16, 2007. http://blogs.guardian.co.uk/art/2007/01/post_14.html

15 Michael Billington, The Guardian Unlimited: Arts blog, January 16, 2007. http://blogs.guardian.co.uk/art/2007/01/if_you_cant_write_honestly_cha.html

16 Andrew Collins, *That's Me In The Corner: Adventures of an Ordinary Boy in the Celebrity World*. Ebury Press, 2007.

17 Alex Petridis, The Guardian Unlimited: Arts blog, January 16, 2007. http://blogs.guardian.co.uk/art/2007/01/The_clue's_in_the_job_ title_cha.html

18 Claire Armistead, The Guardian Unlimited: Arts blog. January 16, 2007. http://blogs.guardian.co.uk/art/2007/01/A_spirit_of_interdepence_cha.html

19 A A Gill, 'A gentle kick in the fundamentals', *The Sunday Times Culture*, August 25, 2007.

20 Dorothy Parker, 'Duces Wild', *The New Yorker*, September 15, 1928.

21 Toby Young, www.tobyyoung.co.uk, October 29, 2005.

22 Mark Kermode, *The Observer*, July 9, 2006.

23 Dirk Bogarde, *Sunday Telegraph*, June 18, 1989, reprinted in *For The Time Being*, Viking, 1998.

24 Roger Ebert, *I Hated, Hated, Hated This Movie*, Andrew McMeel Publishing, 2000.

25 Toby Young, www.tobyyoung.co.uk, February 18, 2006.

26 Kenneth Tynan, *Evening Standard*, May 29, 1953.

27 Giorgio Vasari, *Lives of the Most Eminent Painters, Sculptors & Architects*. Oxford Classics, 1998.

28 Pauline Kael, *Is There A Cure For Film Criticism, I Lost It At The Movies*, Marion Boyars Publishers, 1965.

29 Lester Bangs, 'An Instant Fan's Inspired Notes: You Gotta Listen', 1980.

30 Julie Burchill, 'When Toby Met Julie', directed by Mark Halliley, BBC 4, June 27, 2005.

other titles available in the **creative** ESSENTIALS series

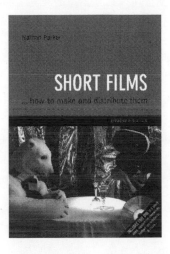

→ DVD features 5 award-winning
short films all discussed as
case studies in the book from
distributor Dazzle Films, including
Being Bad & BAFTA-nominated
Hotel Infinity

→ DVD also includes sample layouts
for budget spreadsheets, release
forms, actor contracts and more

→ Includes interviews with
experienced professionals from
all areas of short filmmaking and
distribution

SHORT FILMS
how to make and distribute them
Nathan Parker

This book is for anyone who has ever wanted to make a short
film. Focusing on the practicalities of filmmaking, it will guide
you through all stages of the process, examining every available
possibility along the way. From the development of your initial
idea, to screening your finished film in front of an audience, it will
enable you to make informed decisions, including which format to
use, where to find cast and crew, and how to get your short film
distributed. An invaluable resource for new and more experienced
filmmakers alike, offering technical and creative solutions for the
realisation of short films in all shapes and sizes.

Nathan Parker is a filmmaker and teaches courses in short
filmmaking and cinematography at Central Saint Martins in London.

978-1-904048-81-7 £16.99

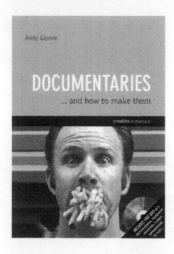

→ Accompanying DVD features
documentaries discussed as case
studies in the book, including the
multi-award-winning *LIFT*, *Boogie
Woogie Daddy* and *Footprints*

→ DVD also includes sample layouts
for budget spreadsheets, release
forms, location releases and more

→ Includes interviews with industry
insiders and award-winning
filmmakers who contribute their
tips, tricks and advice

DOCUMENTARIES
and how to make them
Andy Glynne

From the development of your initial idea, to screening your
finished film for an audience, this book tells you all you need
to know about the craft. It will enable you to make informed
decisions, including which format to use, where to find crew and
how to get your documentary distributed. An invaluable resource
for new and more experienced filmmakers alike, offering technical
and creative solutions for the realisation of documentaries in all
shapes and sizes.

Andy Glynne is an award-winning documentary filmmaker, tutor and
director of DFG – The Documentary Filmmakers Group – the largest
documentary organisation in the UK.

978-1-904048-80-0 £16.99

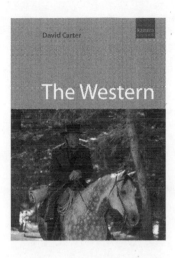

→ Covers directors such as Fred
 Zinnemann, John Ford and
 Sergio Leone, and stars such as
 John Wayne, Clint Eastwood,
 Barbara Stanwyck and James
 Stewart

→ Films discussed include
 *Shane, The Wild Bunch, The
 Magnificent Seven, High Noon*
 and *Brokeback Mountain*

The Western
David Carter

From the very beginnings of cinema in America the Western has been a
central genre. The hazardous lives of settlers, their conflict with Native
Americans ('the Indians'), the lawless frontier towns, outlaws and cattle
rustlers, all found their way into the new medium. The Western became
popular worldwide because it offered escape, adventure, stunning
landscapes and romance; also themes that resonated such as survival,
law and order, defence of family, and dreams of a new and better world.

David Carter's book starts with an introduction to the real American
West and its famous historical figures, and traces the development
of the genre from popular literature, through the early silent films,
the sound era, the Golden Age of classic Westerns, TV and 'spaghetti
westerns', to the self-reflexive and revisionist Westerns of recent decades.
This book provides a basic work of reference for all the major directors
and noteworthy films of the genre.

978-1-84243-217-4 £9.99

→ Accompanying DVD features
 3 horror shorts

→ Looks at renowned directors,
 including Wes Craven, John
 Carpenter, David Cronenberg,
 Dario Argento, Sam Raimi and
 Hideo Nakata

→ For horror aficionados and
 media or film students

Horror Films

Colin Odell & Michelle Le Blanc

The Kamera Book of *Horror Films* takes you on a journey into the realm of fear. From horror cinema's beginnings in the late nineteenth century to the latest splatter films, from the chills of the ghost film to the terror of the living dead, there's more than enough to keep you awake at night.

There's a whole world of terror to explore – Spanish werewolves, Chinese vampires, Italian zombies, demons in Britain, killers in America, evil spirits in Japan.

This book offers a guide to key films, directors and movements, including *Dracula*, *Frankenstein*, *Scream*, *Halloween*, *The Sixth Sense*, *Ringu* and *Evil Dead*, and the more unusual *The Living Dead Girl*, *Rouge*, *Les Yeux sans Visage*, *Nang Nak* and *Black Cat*.

978-1-84243-218-1 £9.99

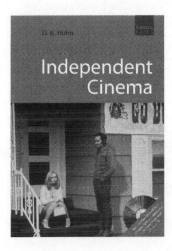

→ **Accompanying DVD features Paul Cronin's *Film as a Subversive Art: Amos Vogel and Cinema 16*, a documentary profile about the founder of the New York Film Festival and America's most important film society**

→ **Includes previously unpublished interviews with Jill Sprecher (*Clockwatchers*), James Mangold (*Walk the Line*) and Guy Maddin (*The Saddest Music in the World*)**

Independent Cinema

D. K. Holm

D. K. Holm aims to define a term all too carelessly used both by media commentators and marketers, and distinguish it from categories such as avant-garde, underground, experimental or 'art' films, with which it is often confused.

By contrasting studio-era Hollywood with changes in the business since the 1970s, and the rise of companies such as Miramax and New Line, it shows the birth of a commercial environment in which the new independent cinema can emerge.

Profiles of specific filmmakers such as Guy Maddin, Jill Sprecher and James Mangold suggest how diverse personalities use independent cinema for individual ends.

978-1-904048-70-1 £9.99

kamera BOOKS

ESSENTIAL READING FOR ANYONE INTERESTED IN FILM AND POPULAR CULTURE

Tackling a wide range of subjects from prominent directors, popular genres and current trends through to cult films, national cinemas and film concepts and theories. Kamera Books come complete with complementary DVDs packed with additional material, including feature films, shorts, documentaries and interviews.

Silent Cinema
Brian J. Robb

A handy guide to the art of cinema's silent years in Hollywood and across the globe.

978-1-904048-63-3 **£9.99**

Dalí, Surrealism and Cinema
Elliott H. King

This book surveys the full range of Dalí's eccentric activities with(in) the cinema.

978-1-904048-90-9 **£9.99**

East Asian Cinema
David Carter

An ideal reference work on all the major directors, with details of their films.

978-1-904048-68-8 **£9.99**

David Lynch
Colin Odell & Michelle Le Blanc

Examines Lynch's entire works, considering the themes, motifs and stories behind his incredible films.

978-1-84243-225-9 **£9.99**